AN INNER SILENCE: THE PORTRAITS OF HENRI CARTIER-BRESSON

Foreword by **Agnès Sire** Introduction by **Jean-Luc Nancy**

with 97 tritone reproductions

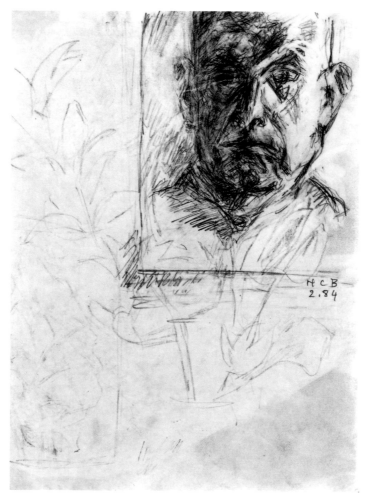

Self-portrait, 1984, François-Marie Banier collection, Paris

Si, en faisant un portrait
on espère saisir le silence
intérieur d'une victime
consentante, c'est très
difficile de lui introduire
entre la chemise et la
peau un appareil photo-
graphique,

Quant au portrait au
crayon, c'est au dessina-
teur d'avoir un silence
intérieur. —

18.1.1996

Henri Cartier-Bresson

If, in making a portrait, you hope to capture the inner silence of a willing victim,
it is very difficult to insert a camera between his shirt and his skin.
With a pencil portrait, it is the draughtsman who must possess an inner silence.

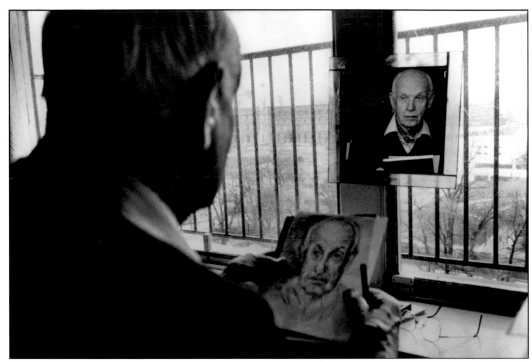

Henri Cartier-Bresson, Paris, 1992. Martine Franck / Magnum Photos

SILENCES

For this exhibition, the first devoted to the Fondation's collection, we have chosen a selection of portraits taken by Henri Cartier-Bresson throughout his life.

The long, ongoing task of cataloguing his work has given us a better grasp of the extraordinary legacy that Henri Cartier-Bresson left to the Fondation.

Why portraits, and why these portraits, the gazes of which shine out so brightly from the necessary dim light of the gallery walls?

For the silence of those who are absent.

For their presence, which allows for no chatter or superfluities – so unlike the pages of magazines, with their love of gossip and anecdote.

And finally, for 'the gaze of the portrait', to borrow the neat expression that Jean-Luc Nancy used as a book title: 'The true portrait, therefore, is… one in which the subject represented is not caught in any action, and does not even show any expression that might detract from the person in themselves.'[1]

HCB would readily see himself in this, for he was always at pains to rid himself of artifice in order to capture or 'bite like a mosquito'[2] his usually willing subject.

Having officially given up reportage at the beginning of the 1970s in order to return to his first love, drawing, HCB nevertheless continued to photograph faces: he never lost his passion for 'the being stripped naked' behind the lens, for the '*tête à tête*' dialogue.[3]

His love of painting led him at the end of the war, after his escape, to photograph artists on behalf of the Alsace publisher Pierre Braun; in this capacity, he was able to pay several visits to Matisse (p. 135), Bonnard (p. 153), Braque (p. 149) and others. 'When I went to see Matisse, I sat in a corner and didn't move; we didn't speak to each other. It was as if we didn't exist.'[4]

Later, sometimes commissioned by prestigious American magazines – *Harper's Bazaar, Vogue, Life* – he met many celebrities whom he was driven to photograph by his love of literature, the arts and research, and by his insatiable curiosity about human beings.

But it was always done with the greatest discretion, on the sly, before the subject could freeze up, in silence.

That is the reason why this collection looks so low-key, avoiding deliberate poses as much as possible: 'Above all, I look for an inner silence. I seek to translate the personality and not an expression.'[5] On the same theme, he liked to tell of his meeting with Frédéric and Irène Joliot-Curie (p. 45): 'I rang, the door opened, that's what I saw, I took a photo, and I said hello afterwards – it wasn't very polite.' Or the meeting with Ezra Pound in Venice (p. 53), which consisted of nothing but a very long silence which 'seemed to last for hours'. Truman Capote (p. 121) described him as 'a frantic dragonfly… Leica glued to his eye… doing his clickety-clicks with a joyous intensity and religious fervor that filled his whole being'.

The Joliot-Curies, Ezra Pound, Truman Capote – three exemplary portraits, three magnificent presences in which the 'dragonfly' manages to capture the eternity of a gaze in the blink of an eye.

And what of the 'victim', the subject who has been caught? Is it a pleasure, a torture, a chore that comes with fame, a 'high-speed kidnapping', or just a composition, as Roland Barthes described it in *Camera Lucida*: 'Alas, I am doomed by (well-meaning) Photography always to have an expression: my body never finds its zero degree, no one can give it to me.'[6]

Perhaps the answer can be found in some remarkably prescient lines that HCB wrote in the introduction to his book *The Decisive Moment*: 'I infinitely prefer, to contrived portraits, those little identity-card photos which are pasted side by side, row after row, in the windows of passport photographers. At least there is on these faces something that raises a question, a simple factual testimony – this in place of the poetic identification we look for.'[7]

Everyone knows of HCB's dislike of cameras pointed at himself. Perhaps he felt the falseness of the situation, like Roland Barthes (p. 77): 'But very often (too often, to my taste), I have been photographed and knew it. Now, once I feel myself observed by the lens, everything changes: I constitute myself in the process of "posing", I instantaneously make another body for myself, I transform myself in advance into an image.'[8]

Perhaps HCB did not want to become an image. But when he drew a self-portrait (p. 4), he was serious, his gaze was intense, almost severe, which for such a 'visual hedonist' comes as something of a surprise.

Was he 'posing'? Or was this really the 'zero degree' of his face? Perhaps the self-portrait at dusk, from the end of his life (p. 10), is the purest expression of this idea: the elusive shadow, the Platonic illusion, the outlines.

In the duel of the portrait, how do you face the gaze of the other? Which of you is giving and which of you is taking? How do you stand firm, as you are confronted with the unblinking eye of the camera, knowing that one likeness, one particular view, will be fixed forever?

'In front of the lens, I am at the same time: the one I think I am, the one I want others to think I am, the one the photographer thinks I am, and the one he makes use of to exhibit his art.'[9] A sort of actor, in fact, in the words of Roland Barthes, who so precisely analysed this moment of posing. HCB did not like to photograph actors, who were 'too professional, they pose immediately'. The few who found favour in his eyes, such as Marilyn Monroe (p. 145), are shown in a true moment of unself-

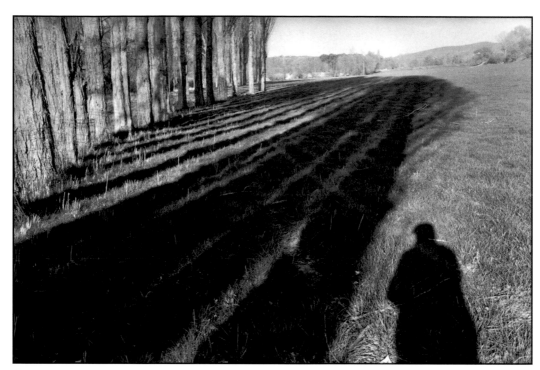

Provence, 1999 © Henri Cartier-Bresson

consciousness. Isabelle Huppert (p. 91) recalled: 'I was aware that he saw something in me that I didn't recognize...; he seizes a moment that is captured by a movement; that's why he's right to do things quickly.'[10]

For the photographer, lightning speed is certainly desirable: at any rate, for HCB 'a portrait is like a courtesy visit of fifteen or twenty minutes. You can't disturb people for any longer than that, like a mosquito about to bite.'[11] To someone whose photograph he was taking and who was waiting uncomfortably for the big moment, amazed that the photographer wasn't doing anything, he announced: 'I took your picture ages ago!'

There is nothing new in the idea of regarding every portrait as a self-portrait – painters have often said as much, and photography as HCB practised it is clearly a very personal view of the world: having nothing to prove, and fully aware that there is no such thing as objective truth, he did not see himself as a journalist, except 'in the sense of a private diary' or sketchbook.

For this reason, it seemed to us that an exhibition of these encounters would not only be one more tribute to his talent as a photographer, but more importantly, would allow many aspects of his being to shine, like so many fireflies in a field, because the gaze of these portraits is his gaze, linked by the thread of the other.

Agnès Sire
Curator

1 *Le regard du portrait*, Paris: Gallimard, 2000, p. 25.

2 Interview with Michel Guerrin, in *Le Monde*, 21 November 1991.

3 *Tête à Tête: Portraits by Henri Cartier-Bresson*, London: Thames & Hudson, 1998.

4 Interview with Philippe Dagen, in *Le Monde*, 11 March 1995.

5 See note 2.

6 Roland Barthes, *Camera Lucida: Reflections on Photography*, trans. Richard Howard, London: Vintage, 1993.

7 *The Decisive Moment*, New York: Simon and Schuster, 1952.

8 Roland Barthes, *Camera Lucida*.

9 Roland Barthes, *Camera Lucida*.

10 Interview in Heinz Butler's film *Biographie d'un regard*, February 2003, NZZ production.

11 See note 2.

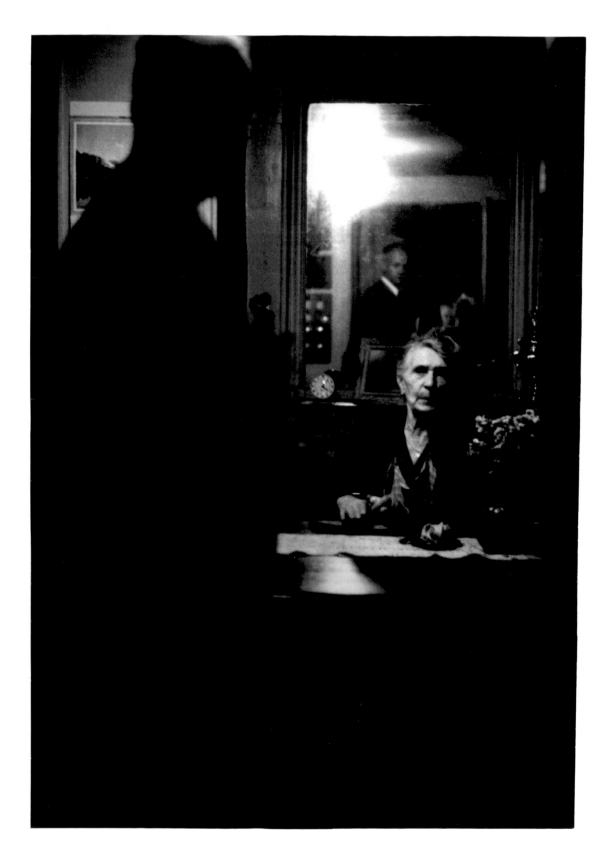

'Madame ma Concierge'

THE GIVEN GAZE

<div align="center">

1

</div>

He gave them his gaze.

Henri Cartier-Bresson gave his gaze to those he photographed, those whose image he captured. He took their picture, both in the modern photographic sense and in the sense of extracting their image from them: in both cases, there is the sense of something coming to light, something being drawn out into the open and so unravelling the enigma of the visible.

The enigma is the substance of what is photographed, this body that is presumed to be a subject, a person: not the body of someone, not the face of someone, but somebody who is there, a fact, a manifestation, an epiphany. Somebody: an aspect, a presence, an expression, a gaze. It is this enigma that is pinned down by a proper name and exposed in a picture. This is the mystery – the true mystery of an image – which like all mysteries can only be explained by itself, though in reality it is not an explanation but an illumination of itself. It is its own light and its own visibility.

The visibility of these portraits can always be seen in the gaze that he gave them. Is it even right to call them 'portraits'? They are not portraits if the word is taken to imply resemblance as the reconstruction of an image, although each of these photographs faithfully *conveys* the appearance of a person, of a body and a face. But this face and body are shown in relation to the world and to themselves: to establish these relationships, to present both what lies in front and what lies beyond (beyond even that which is assumed to lie inside), it is necessary to look. The body must embody a view of the space around it, and ourselves within that space – we who come to gaze upon it, that body or its portrait, that body within its portrait.

It does this through the gaze that it is given. This gaze is not simply 'lent', as one might be tempted to say, but truly given – left there, non-returnable, now its

property, its very own. This gaze is more its property than its own depths, more so than its own intimate self, which it can only perceive through another – one who comes to search for it where only another may find it, where only another may invent it, create it, or simply let it appear.

All his subjects become visible in this gaze, *as* this gaze which belongs to him – yet it is a gaze that he gives away, a gaze that is no longer his, now separate from him and no longer seeing or visible anywhere else, not even to himself, except in and as *their* gaze. HCB is all of them together and all of them individually – a single gaze scattered among hundreds of others, all of those to whom he gave himself in order to make their mystery manifest.

2

Take an example – although every one of them, every man and every woman, is an example that stands for them all, while at the same time occupying a unique place in a series which, with every photograph, is interrupted and cancelled out and yet simultaneously expanded and multiplied, almost beyond all limits.

The gaze of Marilyn Monroe is found caught in a circle of other gazes, or rather of other shots and stares, of cameras and curious faces pressed against the glass – one man, two women – while in the foreground, facing her (as we are and as HCB is), there is a dog whose studded collar highlights its presence, and behind her, there is a partially covered mirror that allows a glimpse of an infinitely repeated scene.

It is impossible to tell if Marilyn was posing for a publicity still, for a film, or for a portrait (in fact, this is the set of *The Misfits*, but the picture itself tells us nothing). Whatever the case may be, the veil on the hat and the plain dress suggest a figure stripped of all provocation. There is still a seductiveness; it is even enhanced, one might say, but it is turned away from us, just as Marilyn has turned her gaze some-where else – towards another camera, or perhaps to nowhere in particular. There is a certain weariness in the gaze, boredom perhaps, but there is an almost imperceptible shadow of a smile on her lips, the suppression of a smile, the portent of melancholy.

The clear shape of the face and the low neckline – wide but discreet, precise, with nakedness withheld, not promised – isolate this image, this icon seemingly caught between the gazes of others, from which her own gaze turns away and escapes; she is offered up and yet lost in the midst of the spectacle – a spectacle herself, withdrawing from the spectacular.

3

Louis Pons – a stuffed bear turns to face us, from between the man and his left-facing reflection, a bear whose glassy stare echoes that of the man and emphasizes his scrutinizing gaze. He is watching, watching himself, worrying perhaps, or perhaps observing himself watching the man who is taking his photograph, how he is taking it, and how he himself is taking it. One might imagine that he is about to bare his teeth like the bear, but in fact, the bear in the portrait becomes a self-portrait from the perspective of the photographer's lens – the self-portrait of HCB the picture-swallower. It's a game, a playful gaze. He is not baring his teeth; he is laughing.

4

Standing, his head and shoulders shown in profile, facing right, Christian Dior turns towards a window, the light from which illuminates him in a classical style – the side lighting playing over the shadows of the face, the folds of the jacket, the buttons and the tie resting on the shirt. We can hardly see his gaze directed at the source of the light, at the day that must lie outside; we can only see his left eye, which seems narrow and almost blank, set in the large face with nose and forehead forming two long, sharp lines and the mouth slightly pinched, the bottom lip pulled back, all combining to convey an impression of attentiveness, evasiveness, not without gravity, even anxiety.

In front of him is a large curtain of light spotted fabric with scalloped edges, its translucent thinness echoed by another bright band behind the head; it unquestionably recalls Christian Dior's art by drawing a contrast between the diaphanous

material and the dark solidity of the body, standing like a monument. Between these two, the gaze melts into transparency itself.

5

Simone de Beauvoir takes up barely a quarter of her picture, standing in the bottom right-hand corner, against a lowered metal shutter (suggesting early morning, or a public holiday), on the pavement of a deserted street, where three lone passers-by in the middle of the road remain blurred and out of focus.

In the haziness of this deliberately vague setting, everything is reduced to the perspective lines of the road and the vertical lines of the buildings and of a tall streetlamp, its height emphasized by the ladder propped against it. Simone's eyes are looking up, away from us and from the street, and her gaze seems to draw up her whole face – from her hair wrapped in a scarf to her parted lips – towards some lofty height; we do not know what this might be or what it might hold, for it cannot be either a spiritual heaven or a waking dream.

But it is a thought, the epiphany of a thought, fierce, spontaneous, elegant, and also playful and tender – a thought that delights in thinking and refuses to yield to the demands of grace or reason.

Note also: Jean-Paul Sartre (together with Fernand Pouillon) was also photographed in the bottom right-hand corner of the image, with the blurred Pont des Arts in the background and, further away, the misty dome of the Institut de France. The lines only move back into the distance, and not up into the brightness above. Therein lies the difference between the sexes.

6

'Madame ma Concierge' is staring at a visitor who has been placed there by HCB expressly in order to capture the gaze of this lady – to give her an object and an objective, and so save her from the task of posing with no one to focus on, which might have disconcerted her. She is thrown into the part that has been set up for her. She is

thrown into the role of receiving and inspecting the unknown visitor ('inspecting', 'visitor' – how wide the lexicon of looking stretches!). The stranger is unwelcome, even intrusive; she looks at him without warmth, without hostility – she is simply on her guard; she looks at the gaze that is focused on her and is reflected in the mirror which, in turn, reflects the glass of the front door, lit up by reflected light (not a camera flash, as a matter of principle); all this creates a glorious classical interplay of infinite reflections, brought to life by the watchful gaze and its mastery of identities. This gaze seems to embody all the intensity of this watchfulness and all her firmly established dignity within her home territory – the clock, the family photo, the vase of flowers, the peeled fruit on a plate.

7

He sits at his desk like any other office-worker, far from the crowded meetings and marches. Martin Luther King is at work; he is occupied, perhaps preoccupied, in any case caught up in his day-to-day tasks – mail, filing – but also caught up by a thought, a question, or perhaps even an escape into memory. This is how the photographer wants him: he has driven his subject into this position, used all his skills to distract him from the camera, pressed him into place before pressing the shutter, weighing down on him as can be seen from the hand on which Martin Luther King rests his forehead – the large hand that holds him up and yet also withholds his gaze from us, or from anything else; his eyes gaze at nothing through the crook of his arm, while his right hand, idle for the moment, clings in mid-air to the pen or pencil it is holding.

HCB looks at him not looking, and reflects this lack of gaze back to him, in reflection, in contemplation, or in despondency, in a kind of inertia that threatens to become overwhelming, signified all around by the mass of papers, telephone, radio, hat carelessly discarded on a pile of files, paper knife, and all the paraphernalia of everyday business, in the midst of which, as we all know, lay the endless struggle for a dream.

8

Coco Chanel, Oppenheimer, Braque, Char, Capote, Leiris were other examples, alongside de Beauvoir and King, of the way in which HCB sometimes allotted only a portion of the image to his subjects – as if they were admitted almost on sufferance, as incidental to their own portraits. The gaze wandered among the signs that both guided it and fragmented it, focusing and distracting – signs that informed the portrait, simultaneously instructing, signifying, putting in order, acting as agency, as composition, as *raison d'être*, as reason rendered by a gaze.

Each of these signs and signals gazes back at us through the photographer's eyes, stamped with the monogram HCB, through which we know that he never missed a clue, if not when taking the picture then certainly when selecting images. Each one is testimony to his composed gaze, in both senses of the term: positioned and ordered, calm and attentive.

9

On the other hand, Jacques Prévert, Jean-Marie Le Clézio and his wife, Carl Jung, Marie-Claude Vaillant-Couturier and Ezra Pound are all typical of a different style, in which the subject takes precedence – what one might call, in the terminology of painting, a more autonomous portrait, avoiding any suggestion of a posed scene. In this case it could be said that all the signs are assembled within the subject, between the lines on the face, the lips, the hands. The subjects absorb the entire meaning in their own gestures and expressions, to the point almost of superappropriation, creating an exaggerated embodiment of their subjectivity, their enigma. They react in different ways to the gaze that is given; they do not turn it away, nor do they send it back to the infinity from which it came, but they treat it more tenderly, more emotionally, more concerned at finding themselves reduced to this strange intercourse with the lens, this interview that has no limits, no objective and no return: each gaze is dependent upon the other.

10

To contrast these two photographic modes, one could say that in the first, HCB's gaze announces and affirms itself through a closed system of *views* that are both limited and recreated by the framing, whereas in the second, his gaze both seeks and loses itself in the gaze of the subject, who absorbs all possible views.

Of course, this is an oversimplification, and there are a great many mixed or intermediary modes.

For example – again, one among many, and all of them distinct from one another – the portrait of Matisse, in which the subject takes the central role, but shares it with a large patterned Chinese wall-hanging; it is slightly out of focus, but this enhances rather than reduces the effectiveness of the sign – a great sign for art, a flag or banner filled with lines and panels that seem to float like vapour rising from Matisse himself; and at the same time his head, with the gaze of a dreamer, turns away, one finger to his lips to emphasize the contemplative silence, perhaps even forbidding conversation, letting his great body sink all its weight into the deep, thick fabric of the housecoat.

11

In every mode in which he works, HCB's gaze is given – I would say that he is devoted to his vision; he plunges into it until it lets him escape into the photograph and then return to us from the image which he has allowed to be created, which he has allowed to come forth, to rise to the surface of the subject and the setting, all exposed now, made explicit in him, through him, by him, leaving their impression on the film and on our eyes.

The gaze settles, unsettles, lets itself alight on objects or even on another gaze – that of the other, which as a gaze is always the same, part of the infinity of all gazes, because vision itself is always the same, the vision of a person who views the world, views someone in the world, and views the world *of* that someone in the world.

Sight is seeing, and a sight is the subject of seeing; a gaze is a controlled opening towards the deepest depths, the hidden things, the secret places. They become visible when they are seen, and this means receiving a gaze, but the gaze must be truly and irrevocably given.

Take another example (*exemplum, eximo*: something taken from a shared and indistinct set of circumstances): the certificate hanging on the wall behind Martin Luther King's desk only becomes visible when it takes on something of HCB's gaze and, along with this, something of Martin Luther King's gaze as made visible by HCB's gaze, which shows him plunged into thought, which is made visible through his eyes. His eyes do not connect with the certificate hanging behind them, and its everyday presence would never hold their gaze, unless due to the influence of some fleeting memory. But now this certificate itself is gazing, turned towards us as it is, and signalling to us that King has a title, a degree, a profession, an honour, a membership. It gazes out at us, to stir our curiosity or our lack of interest in an object that is visibly far from the thoughts of the person portrayed here. And so, as a result, we are either curious or uninterested, the certificate is either exposed or obscured, there is either a presence or an absence in the *gaze* of the person who can turn it into a sign or not, or even turn it into a sign of the exhaustion of meaning.

12

Whatever it is that confronts us also regards us: 'regard' here has more than the sense of an eye looking at an object; it concerns us, penetrates us, matters to us – it is our affair. And so we are involved in the multiple meanings that are brought together in the single, simultaneous fusion of the photograph – whether it be the hat, the paper knife or even the moustache of Martin Luther King, or the collar of the dog in front of Marilyn.

It all makes sense, and it makes for sensibility – it is a sense placed before our eyes like an imperceptible touch. What HCB gave to his subjects was an air, an aura,

an allure; these portraits convey a manner, a disposition, a *habitus*, an *ethos*, a mood, a grace and a favour, a gaze and a gift; the gift he has given to them.

But this gift was only possible because they accepted it – the men and the women who are sometimes wrongly called his 'models', or his subjects. (Isn't a gift only given when it has been received and accepted?) They drew him towards them, and he was drawn into their mystery, into the bright, silent substance of their being. He had to be seized by this substance to be able to give himself over to it. He never knew when or how he gave himself; that precise moment of space–time remained something that he did not know, however much he considered and pondered it. It was the point and the moment of the gift, of the substance and the certainty that never gives reasons for itself, because the reason lies in the other, in the image rendered unto itself, taken from invisibility and absence and immediately given back to it. Every image that gazes at us withdraws its gaze, whether in the details and in the shadows, or in broad daylight and head on – but this withdrawing is in fact the secret of the gift.

Jean-Luc Nancy

Jean-Luc Nancy, born in 1940, is a philosopher who has taught at the Université Marc Bloch in Strasbourg since 1968. He has lectured at universities worldwide, including Berlin, San Diego and Berkeley. His many books include *The Muses* (1996), *The Sense of the World* (1997), *Being Singular Plural* (2000) and *The Speculative Remark: One of Hegel's Bons Mots* (2001).

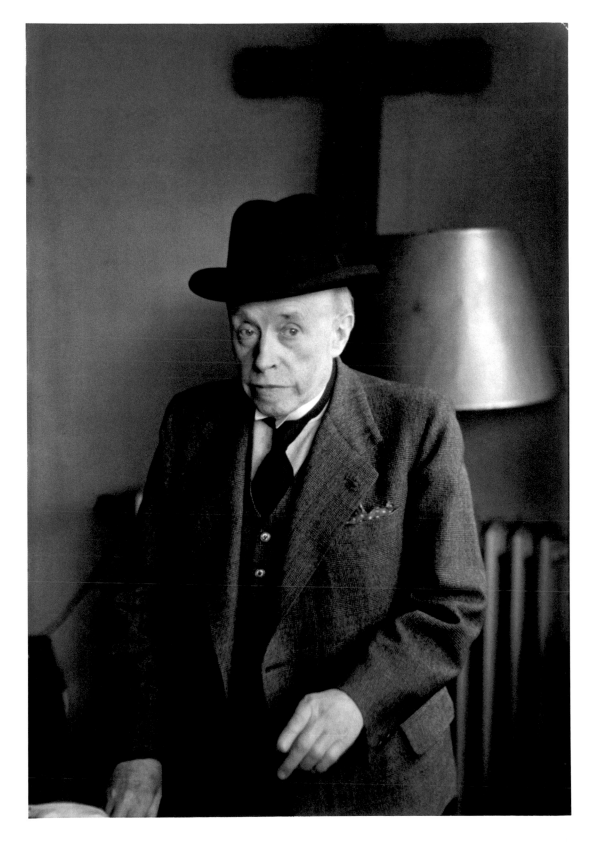

Georges Rouault

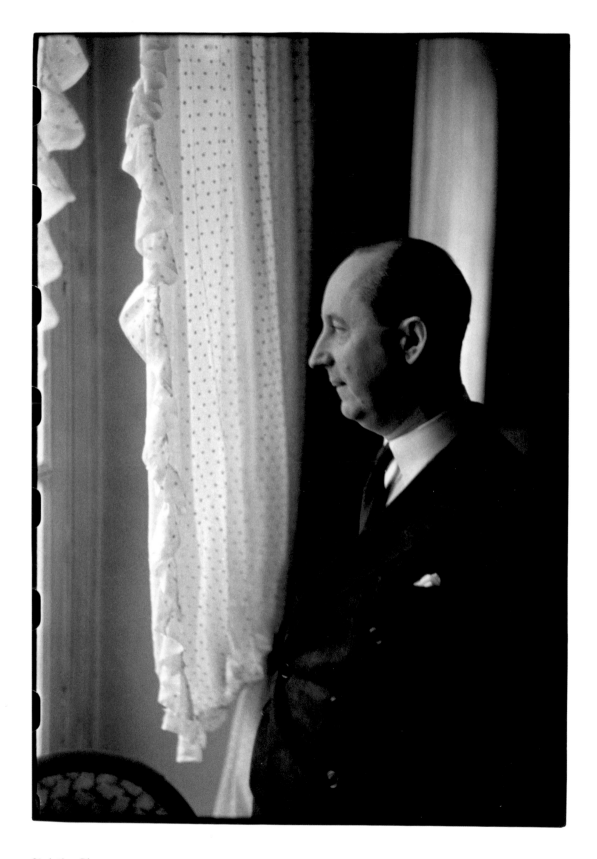

Christian Dior

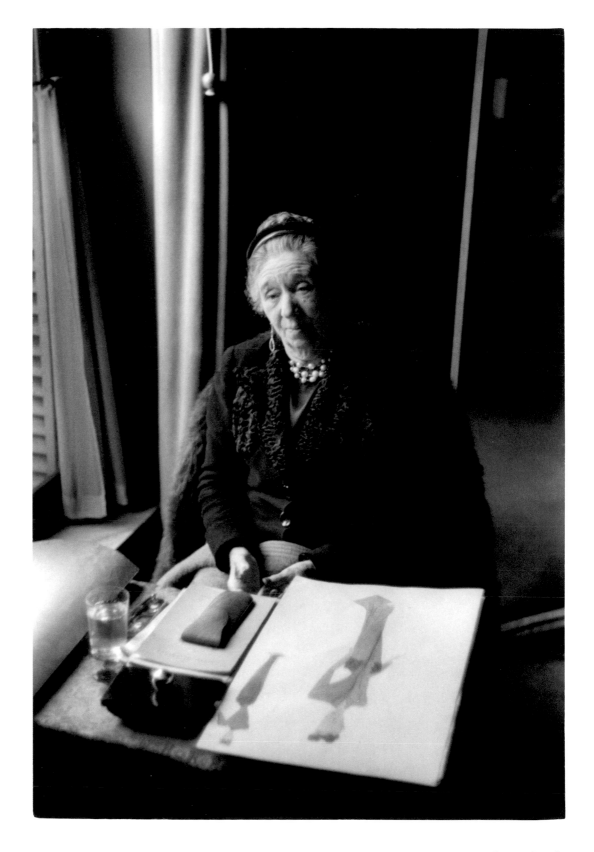

Jeanne Lanvin

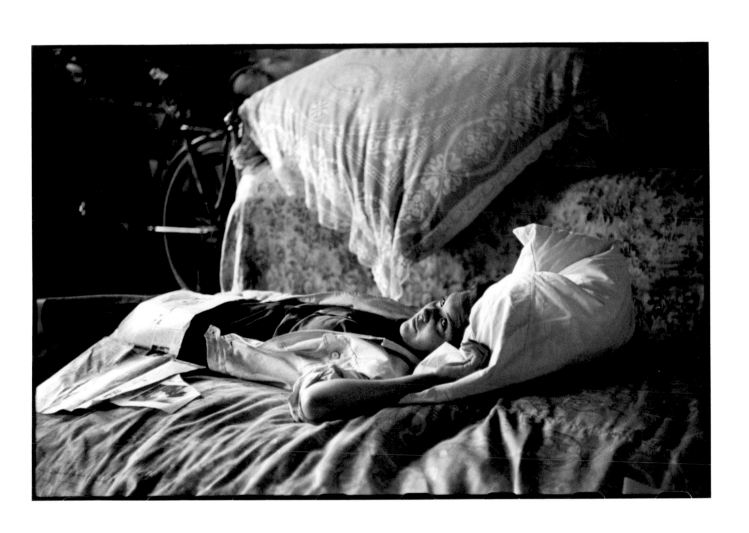

Nicole Cartier-Bresson

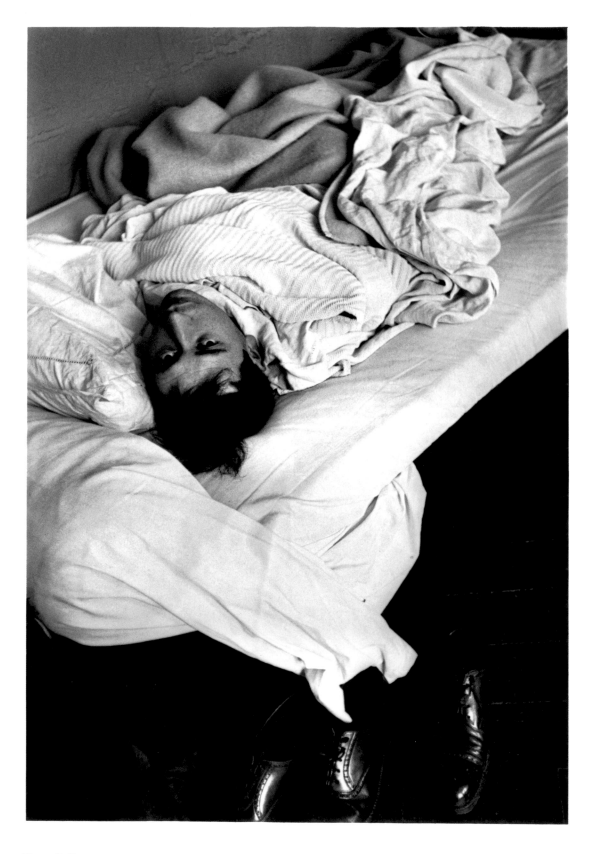

Pierre Colle

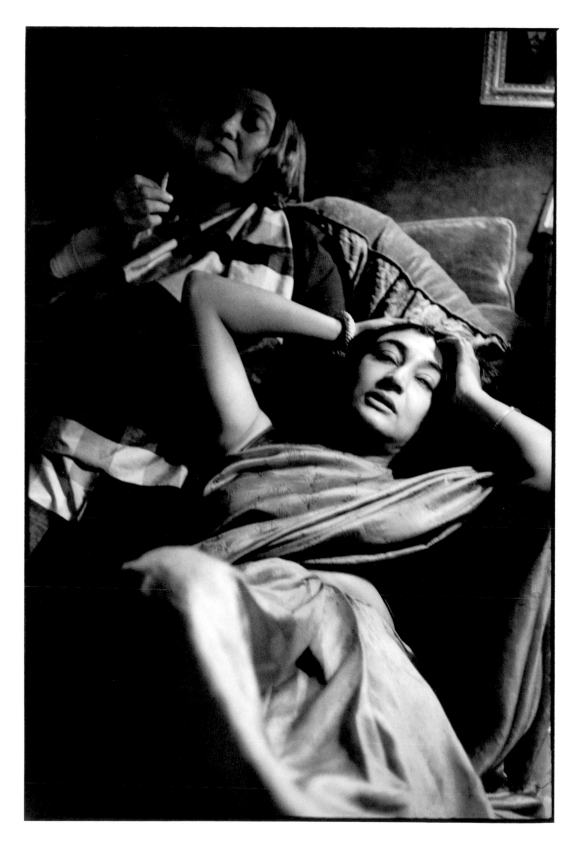

Mary Meerson and Krishna Riboud

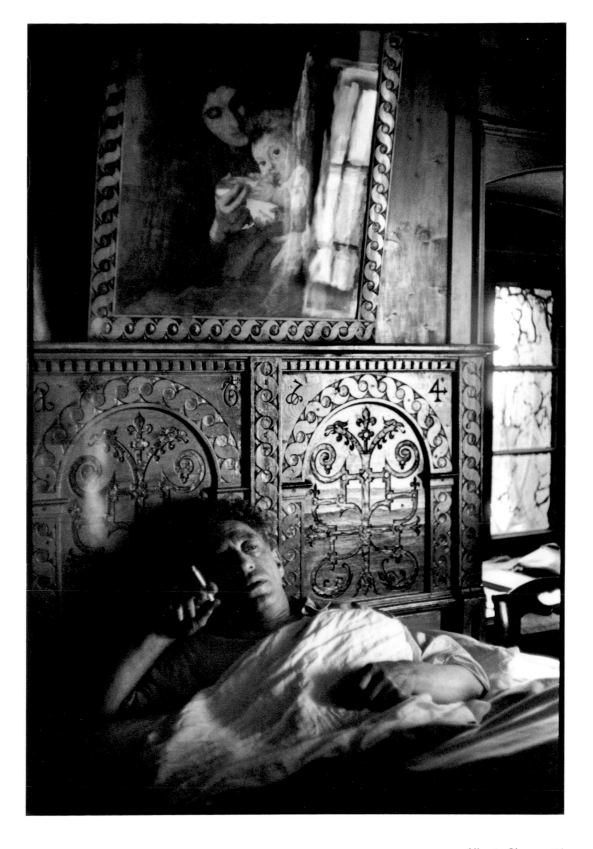

Alberto Giacometti

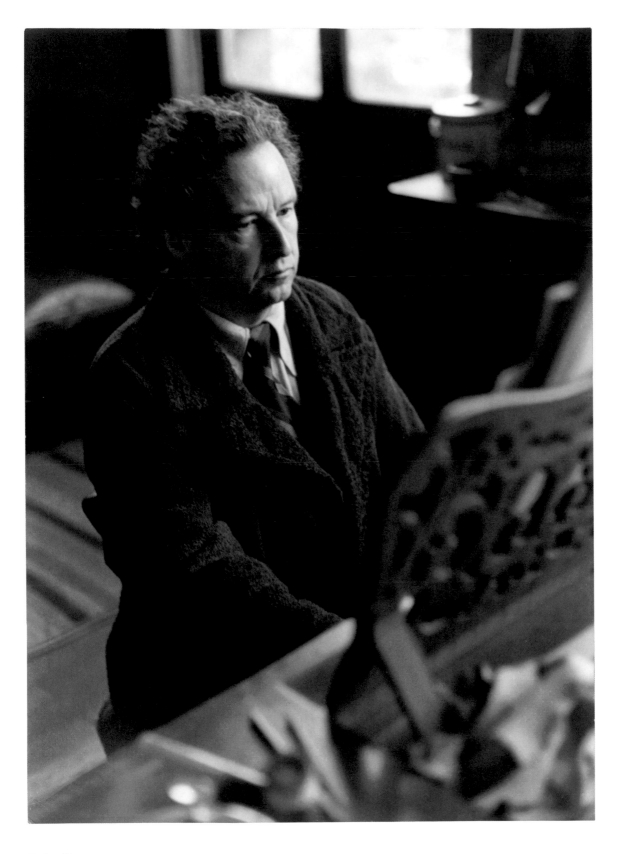

Arthur Honegger

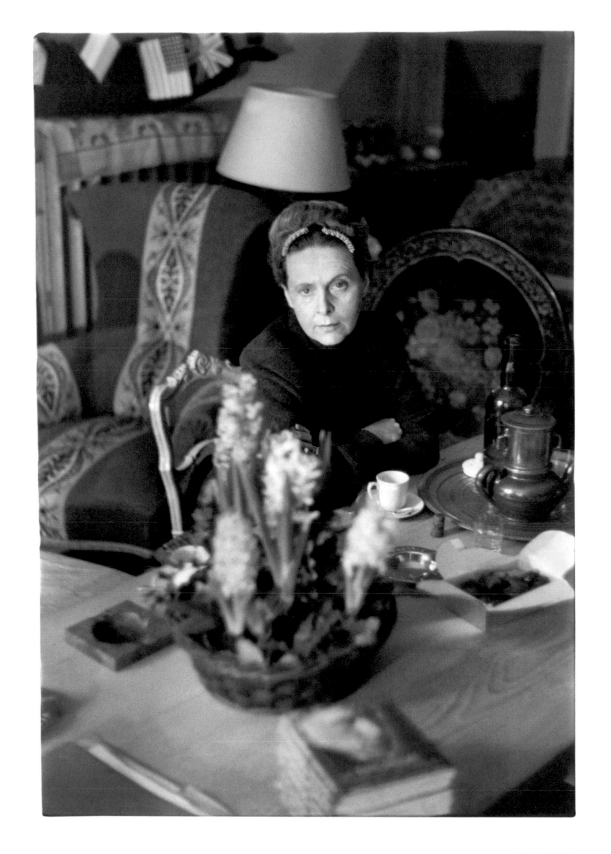

Elsa Triolet

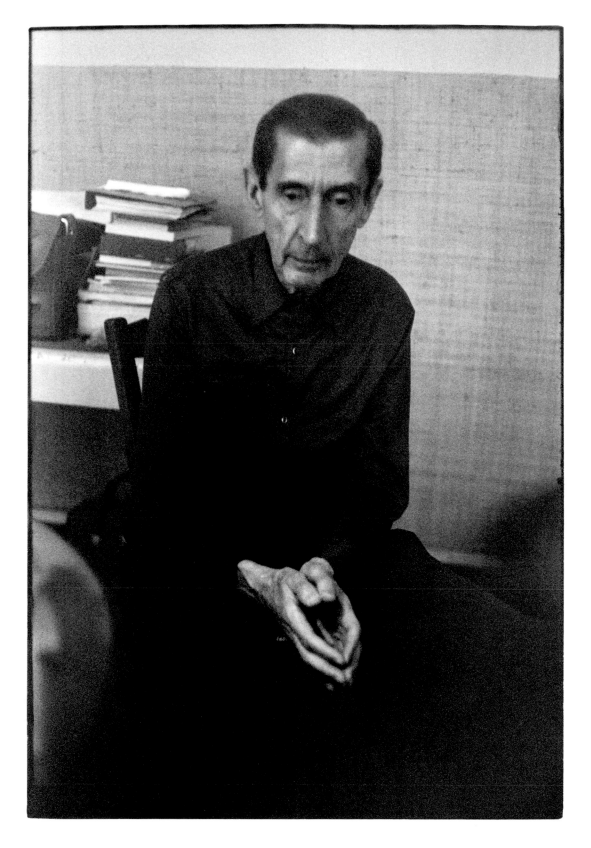

José Bergamin

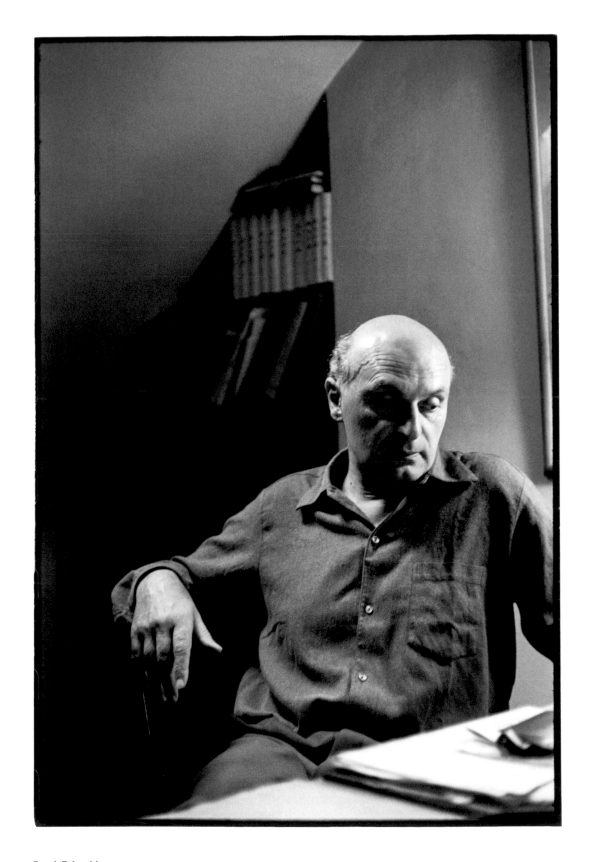

René Etiemble

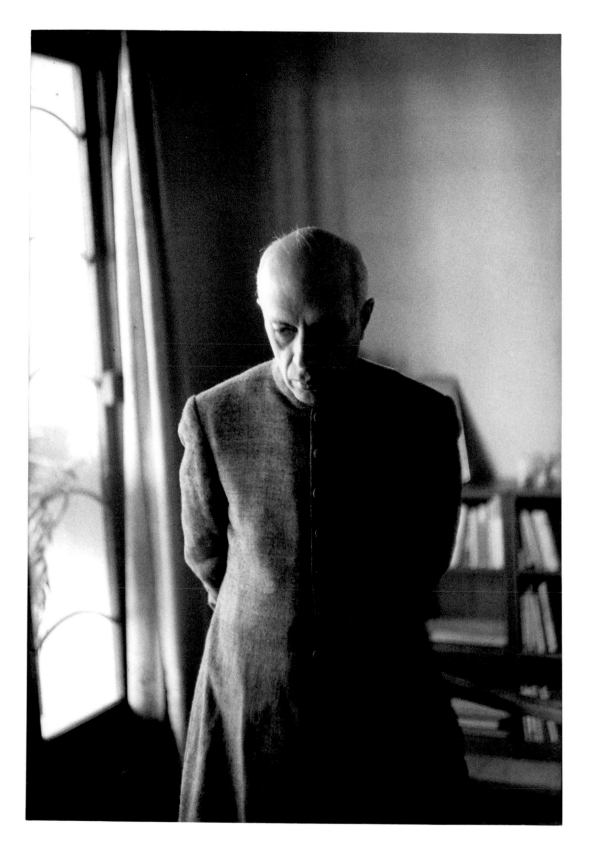

Jawaharlal Nehru

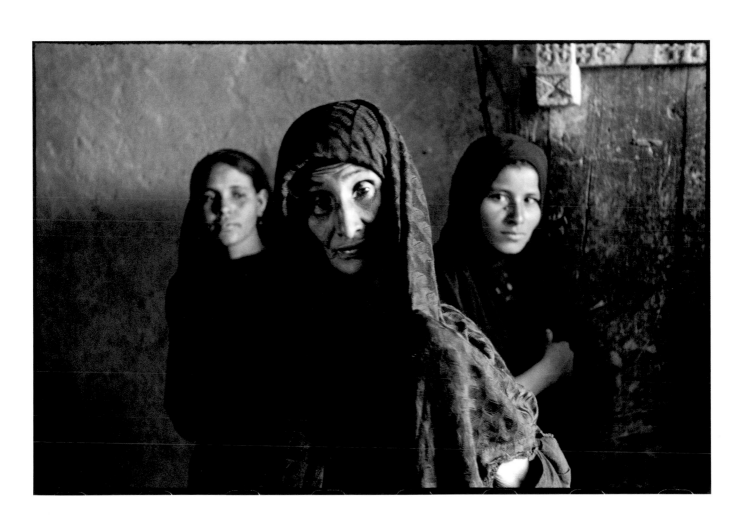

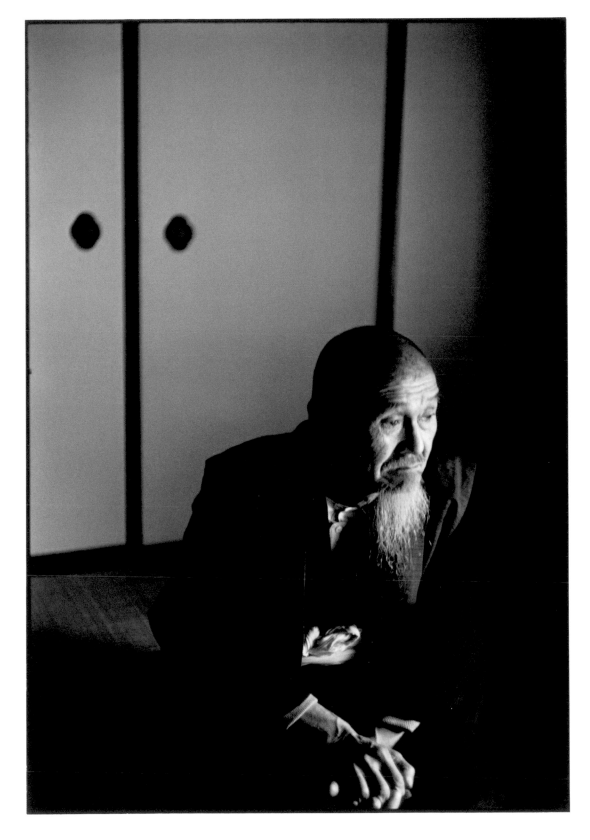

Koen Yamaguchi

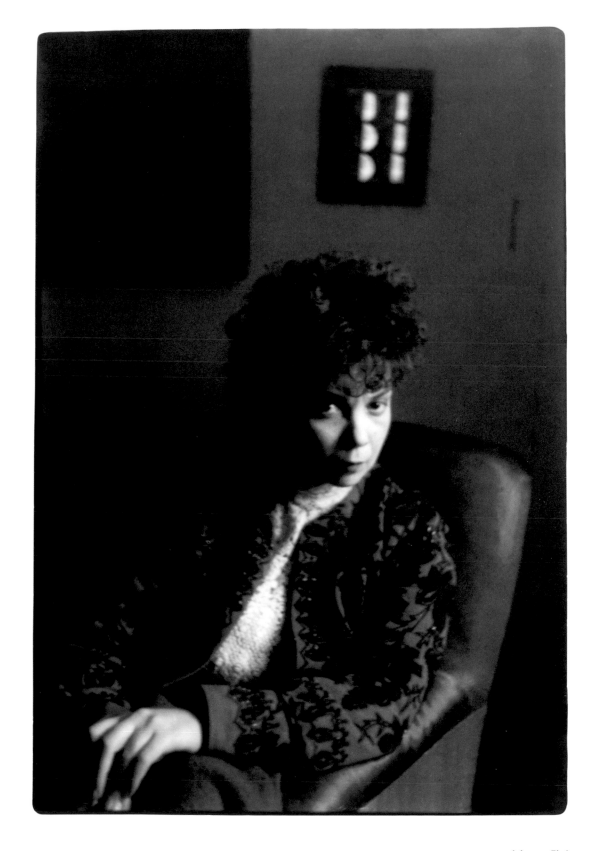

Léonor Fini

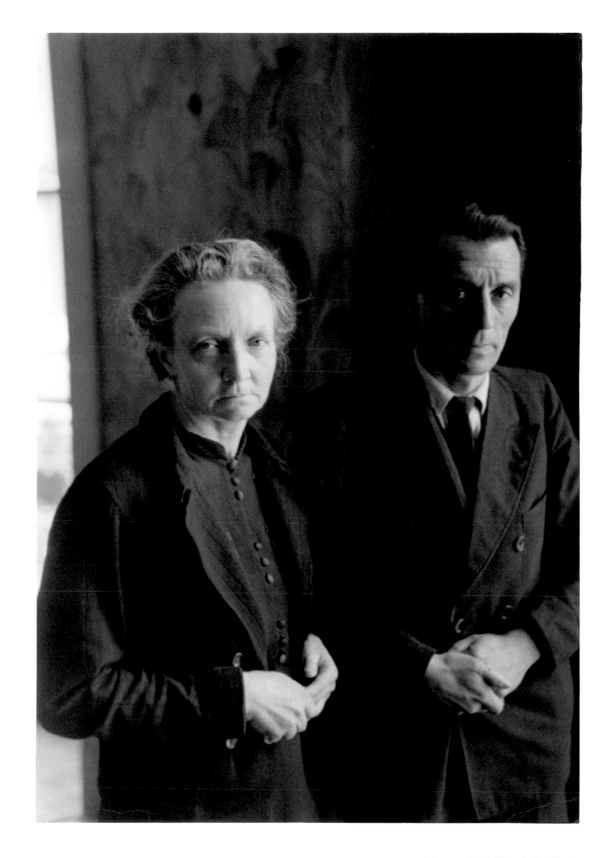

Irène and Frédéric Joliot-Curie

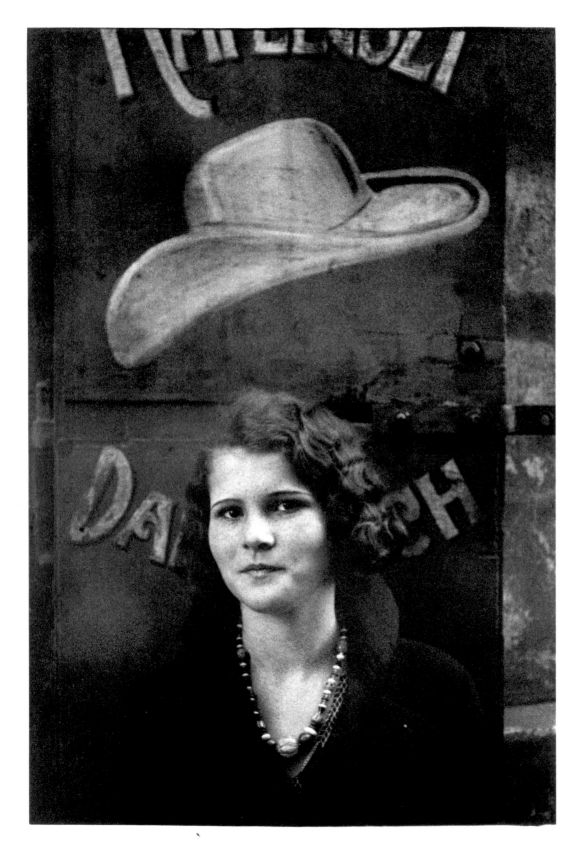

Cracow

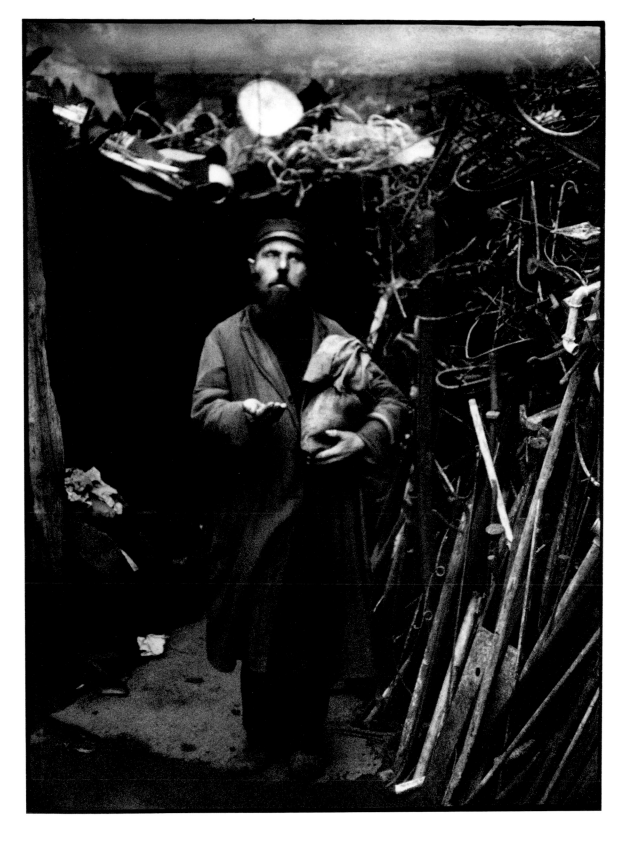

Jewish ghetto, Warsaw

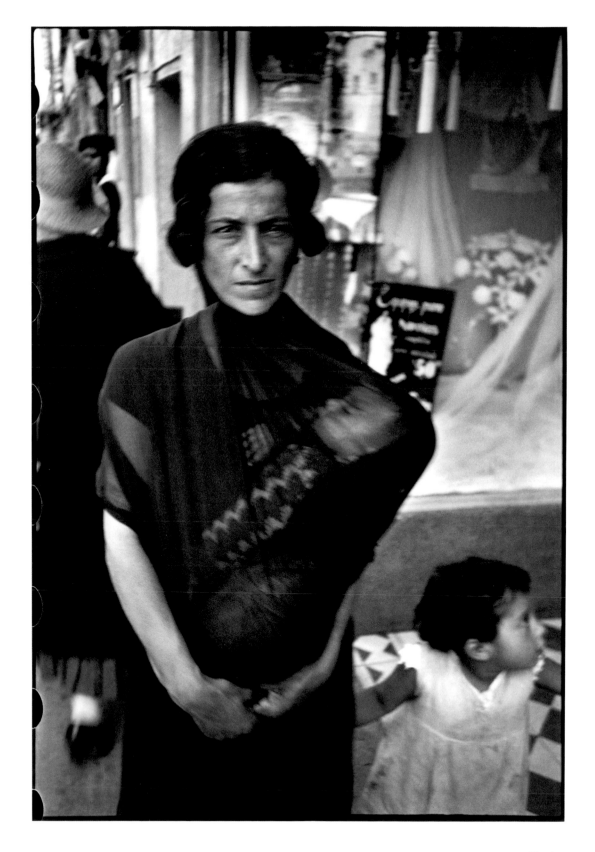

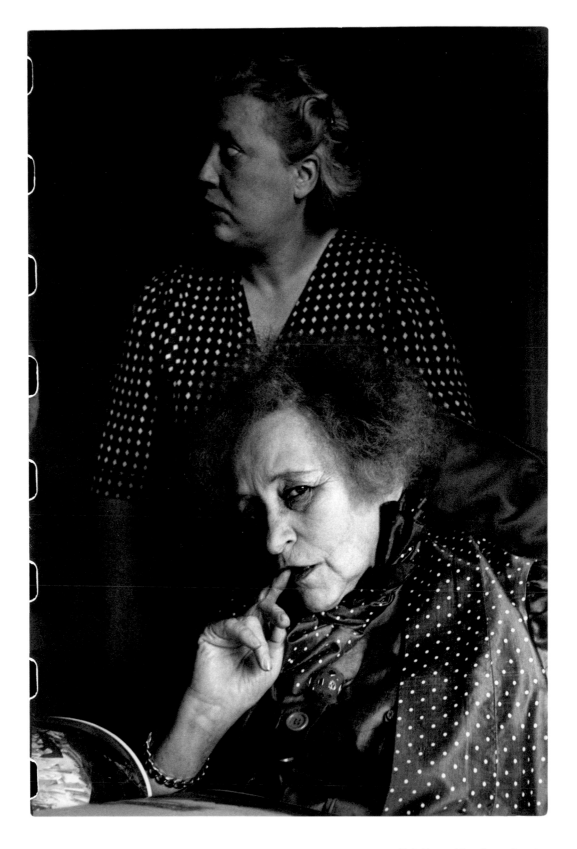

Colette and her housekeeper

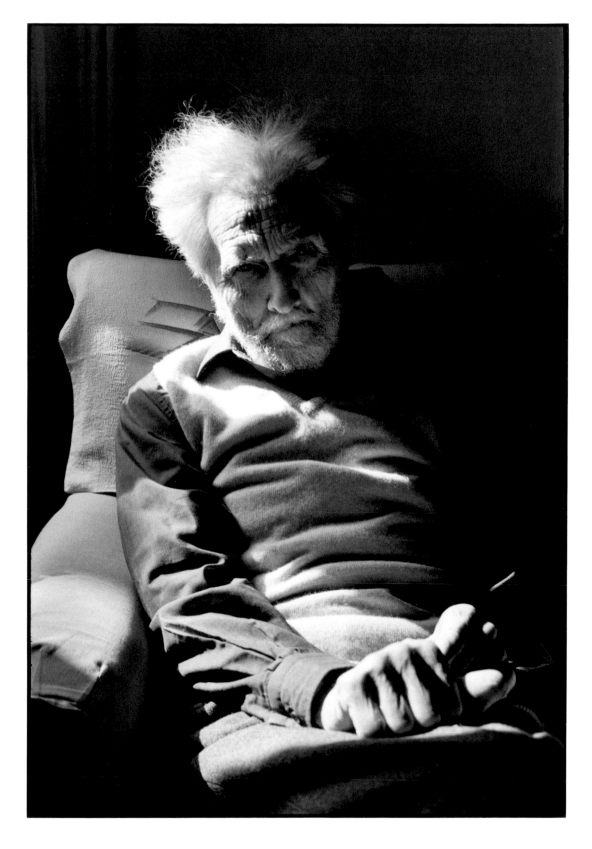

Ezra Pound

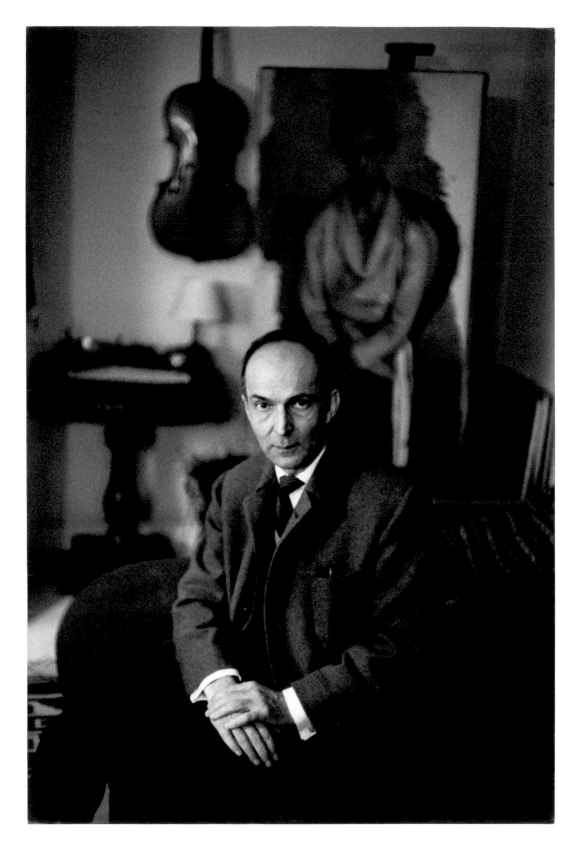

Igor Markevitch

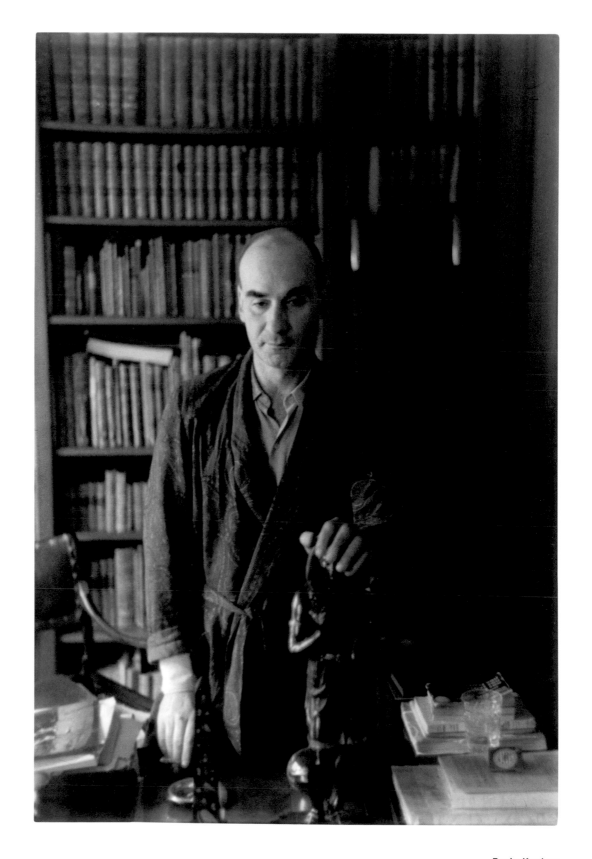

Boris Kochno

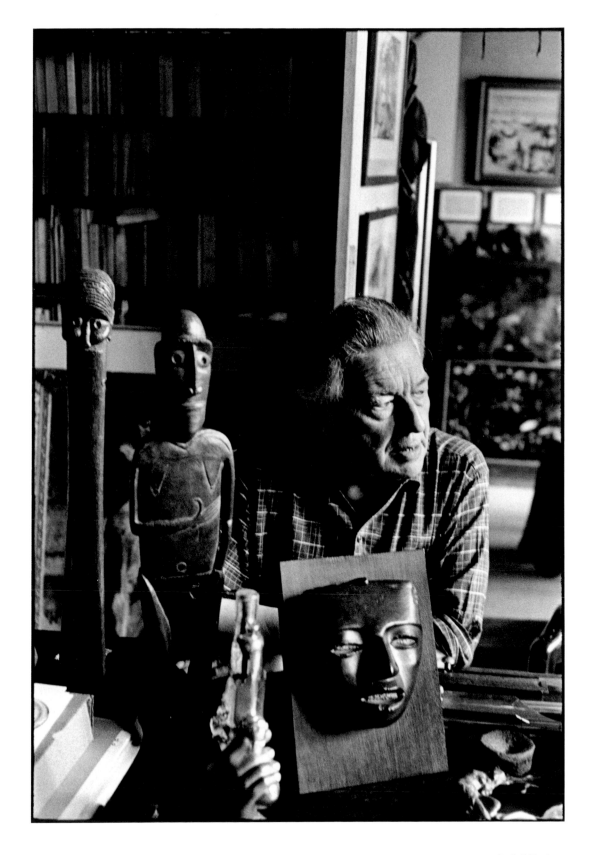

André Breton

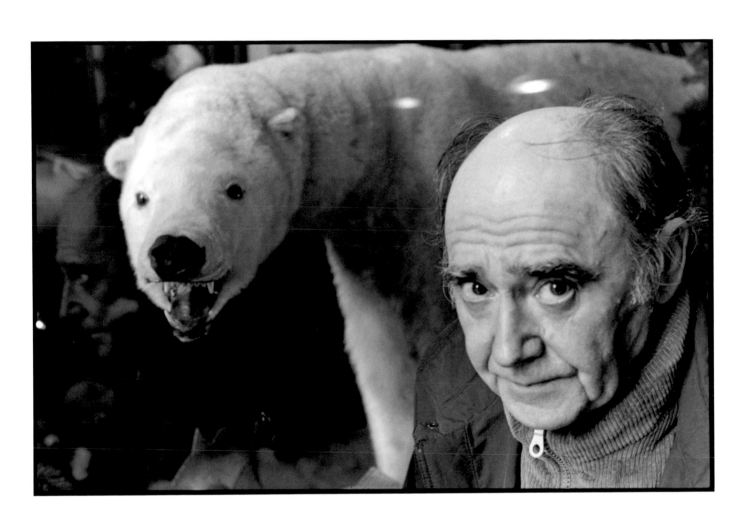

Louis Pons

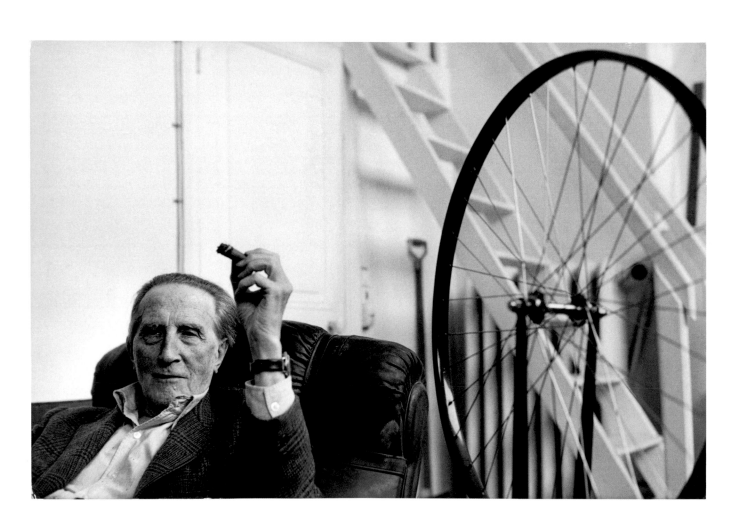

Marcel Duchamp

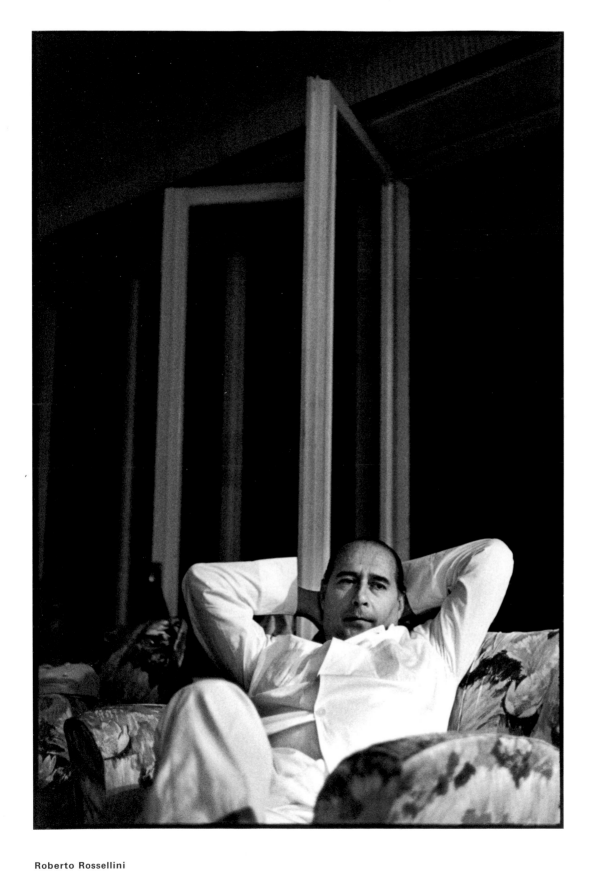

Roberto Rossellini

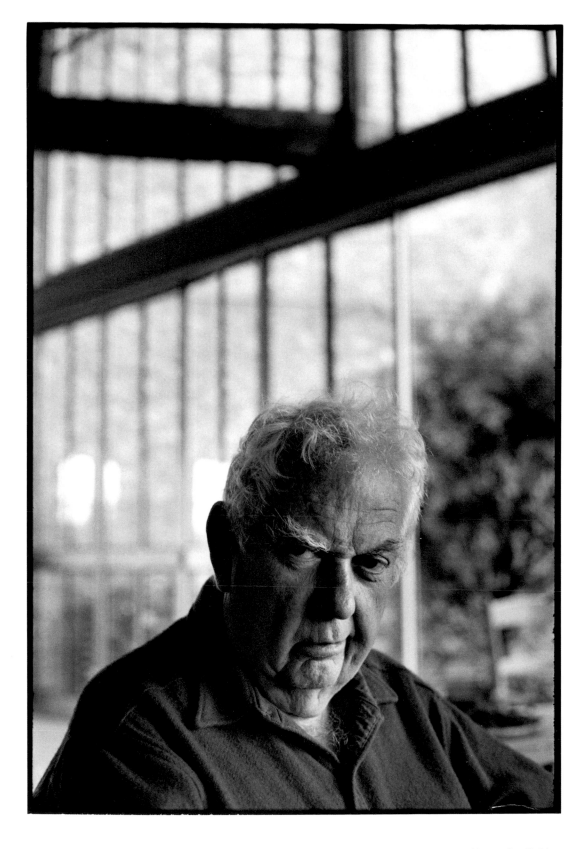

Alexander Calder

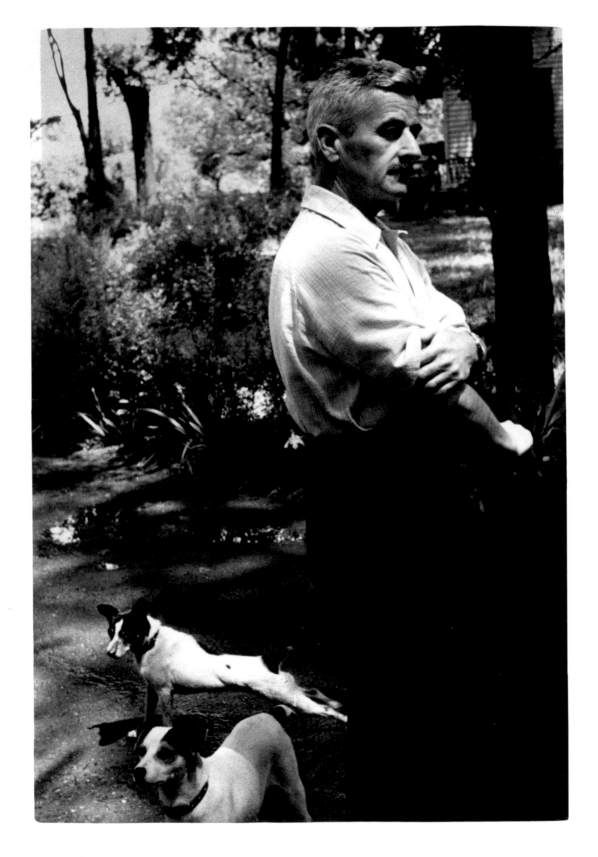

William Faulkner

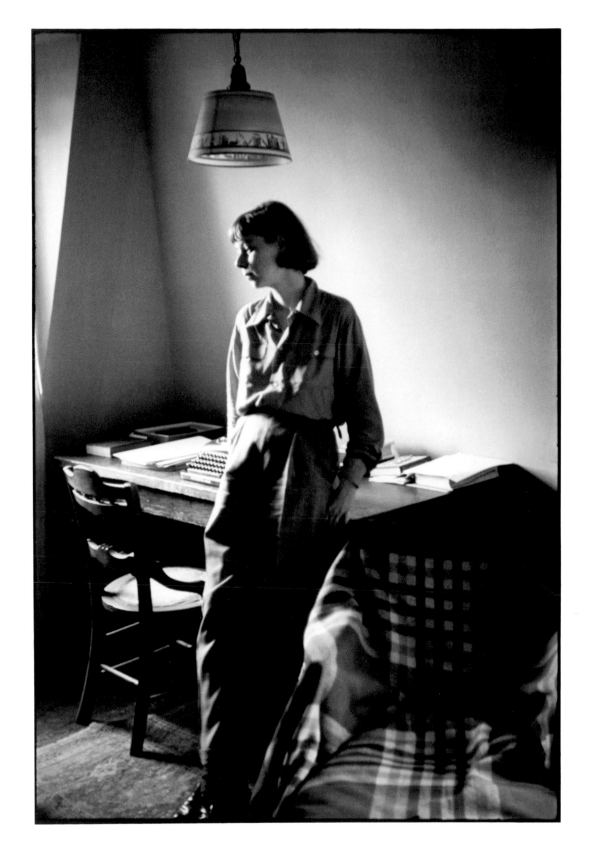

Carson McCullers

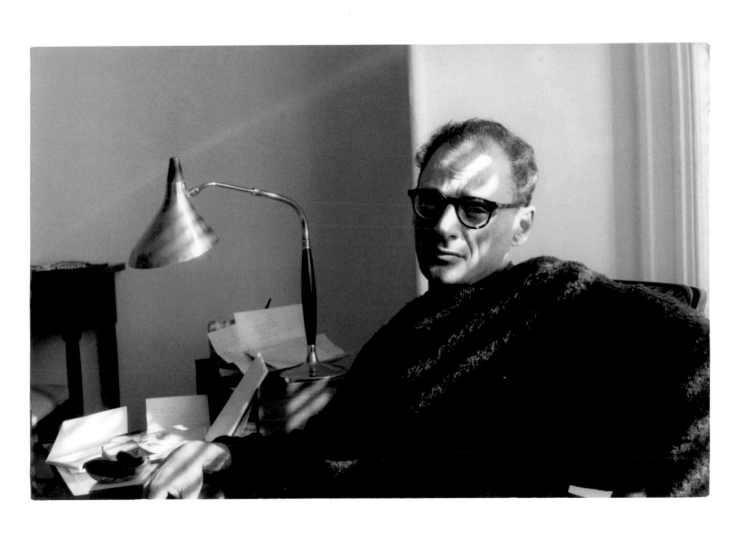

Arthur Miller

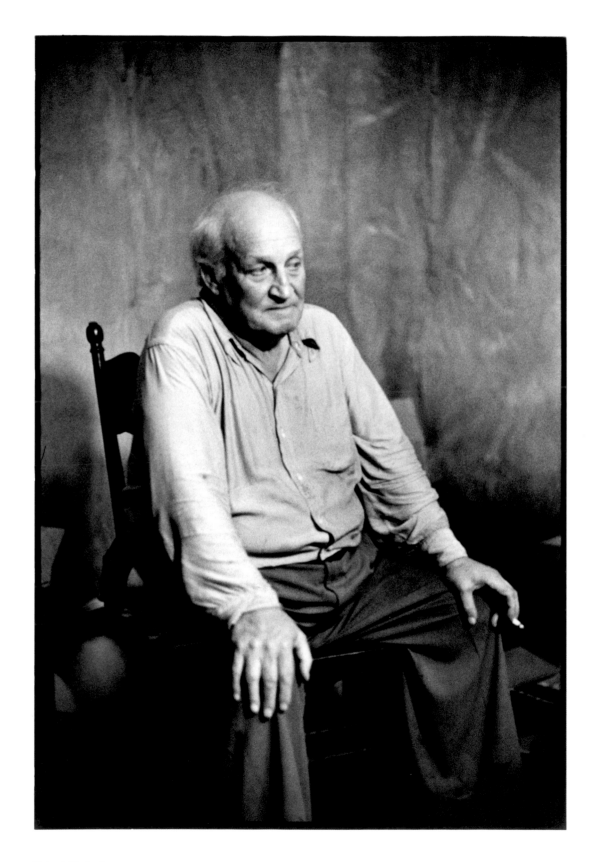

Robert Flaherty

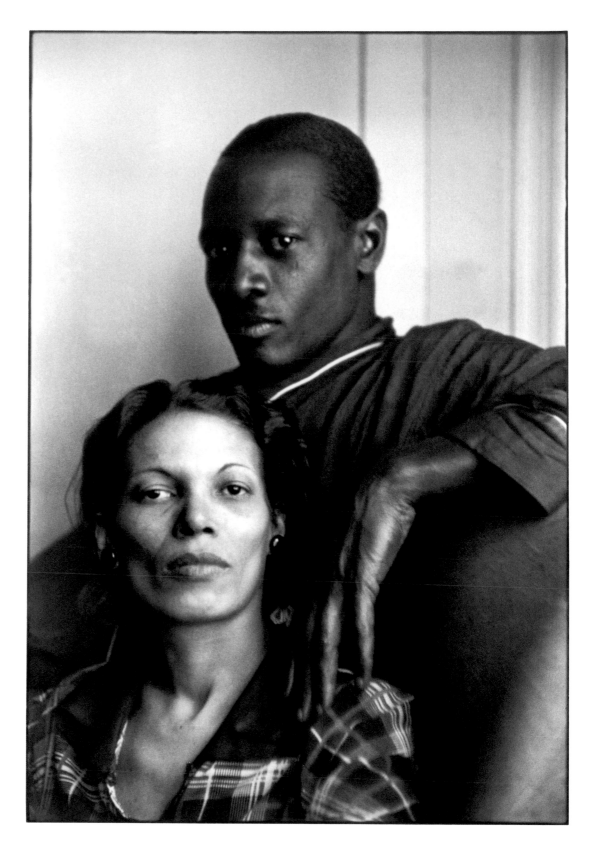

Joe the trumpeter and his wife May

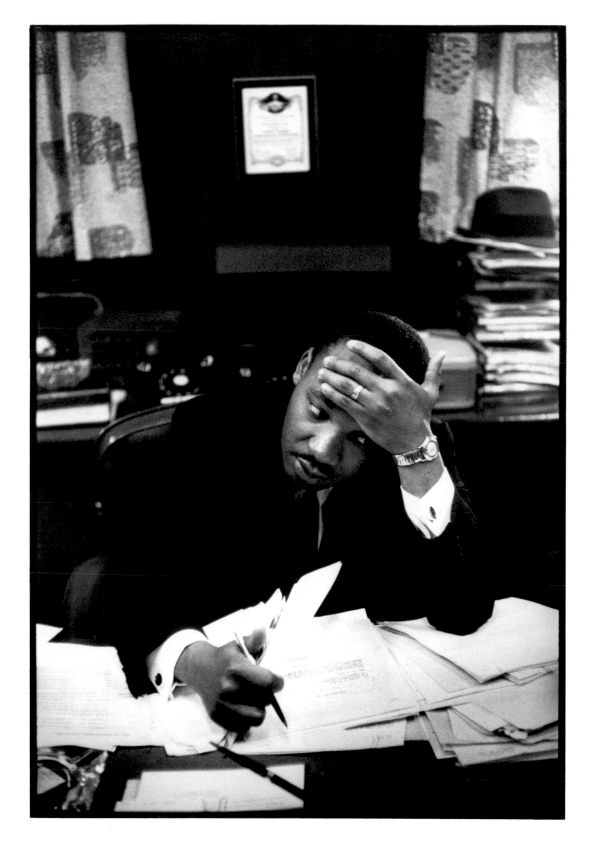

Martin Luther King

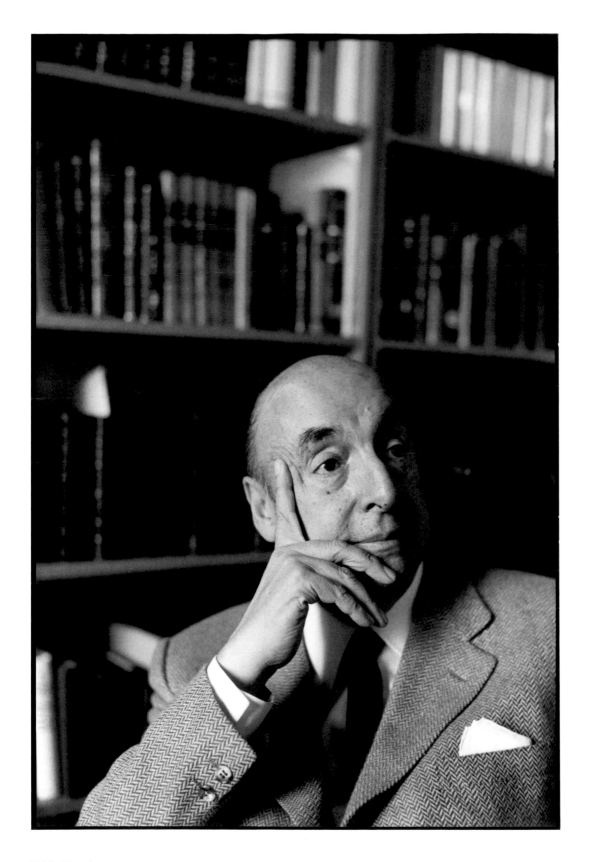

Pablo Neruda

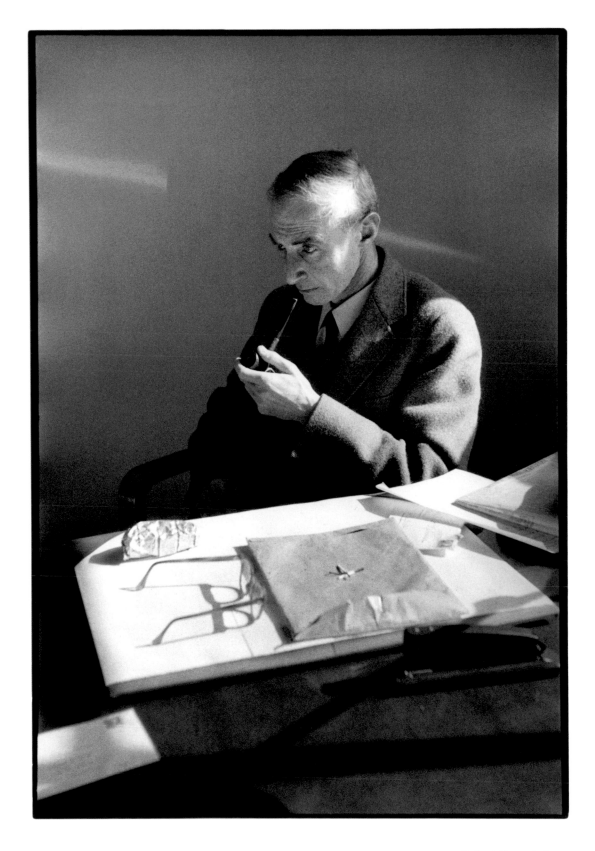

Robert Oppenheimer

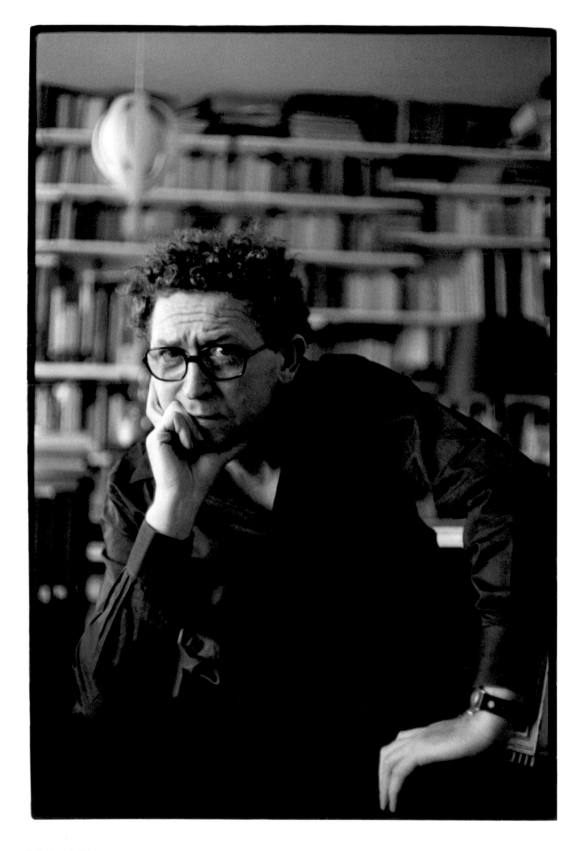

Avigdor Arikha

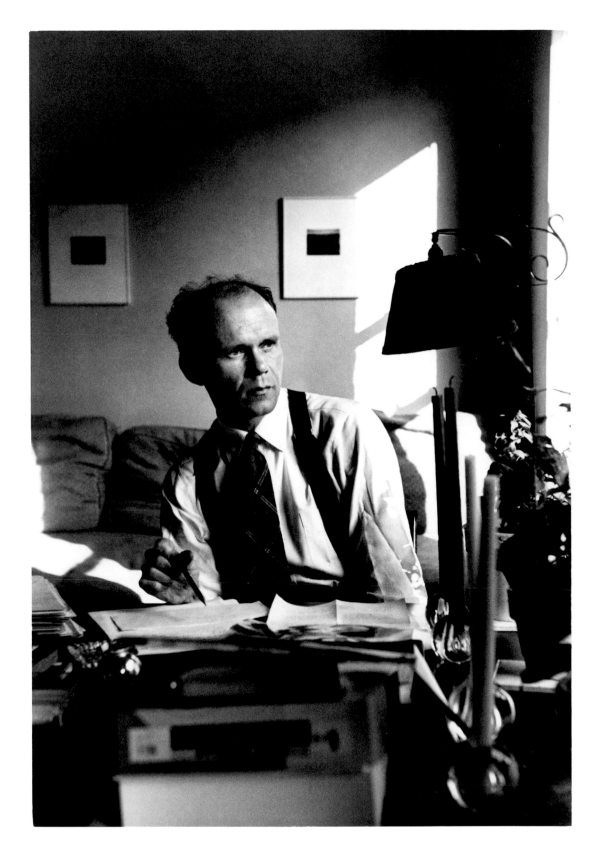

Beaumont Newhall

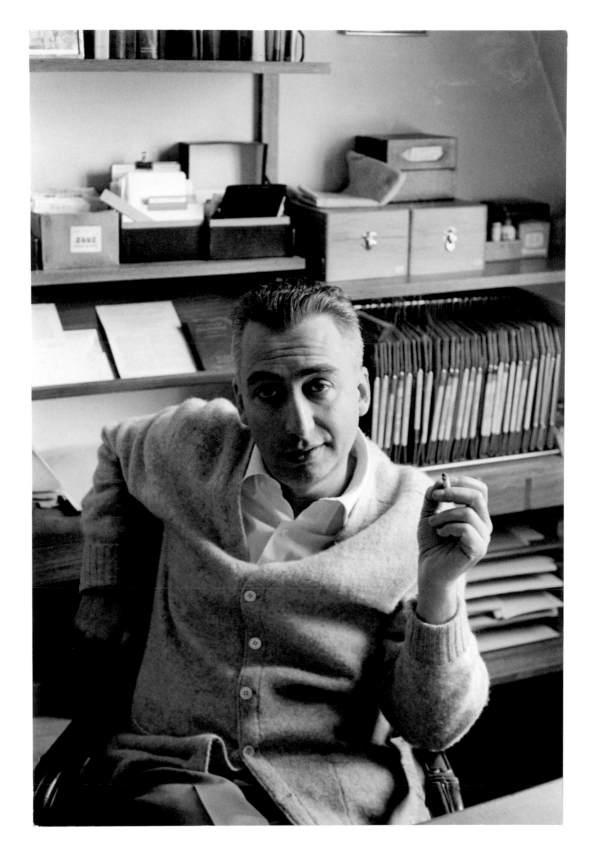

Roland Barthes

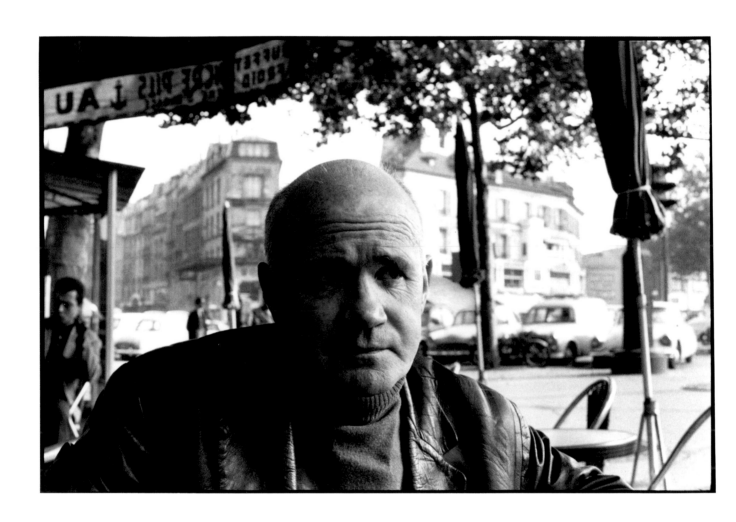

Jean Genet

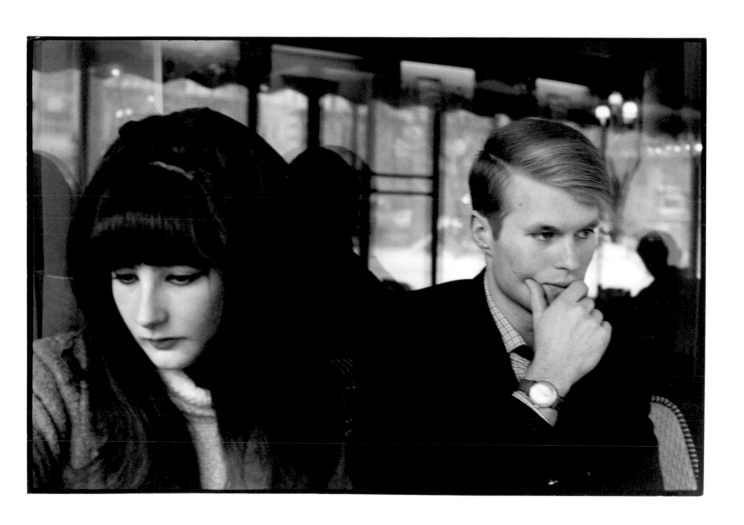

Jean-Marie Le Clézio and his wife

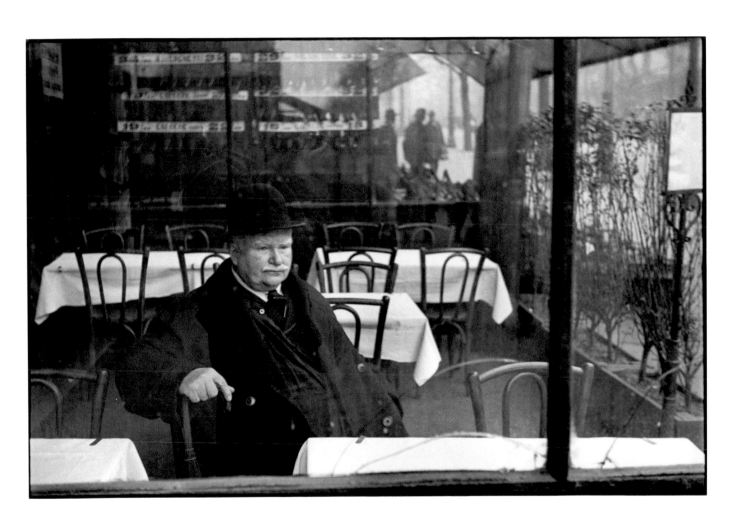

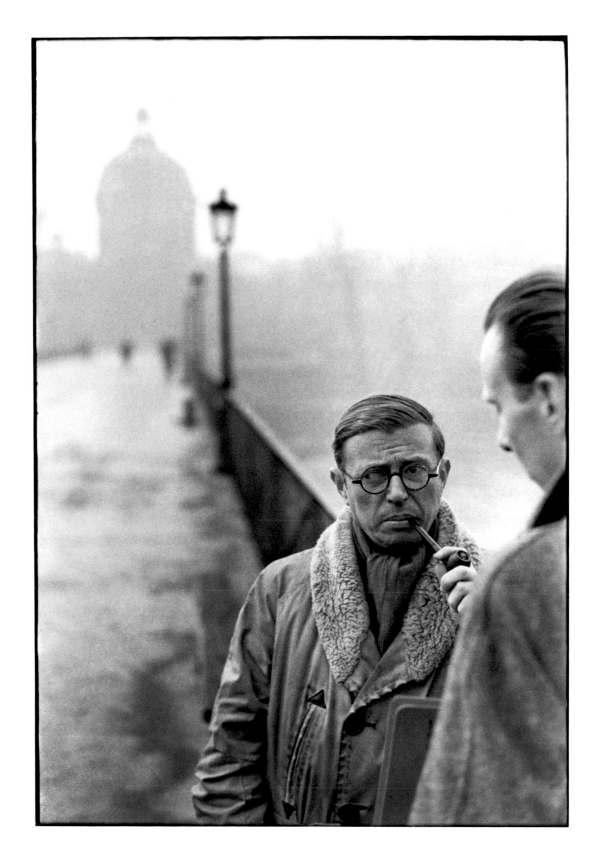

Jean-Paul Sartre and Fernand Pouillon

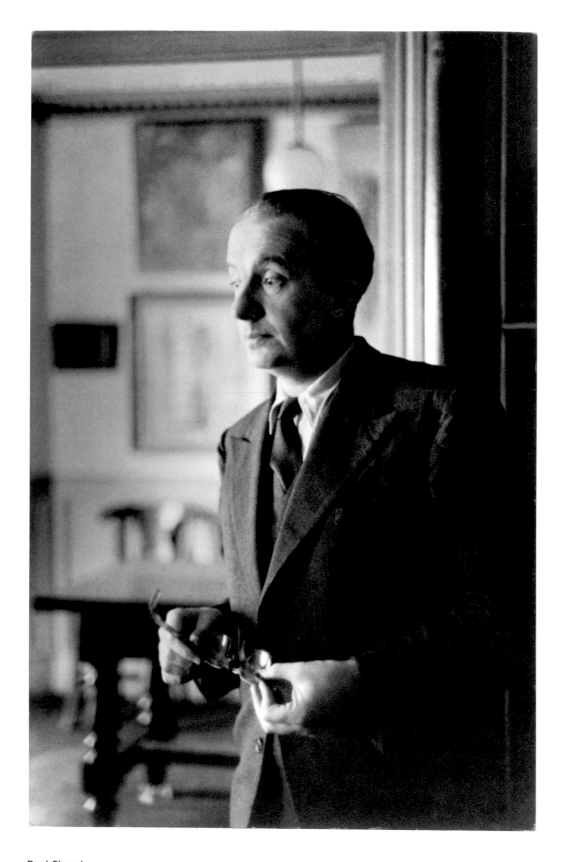

Paul Eluard

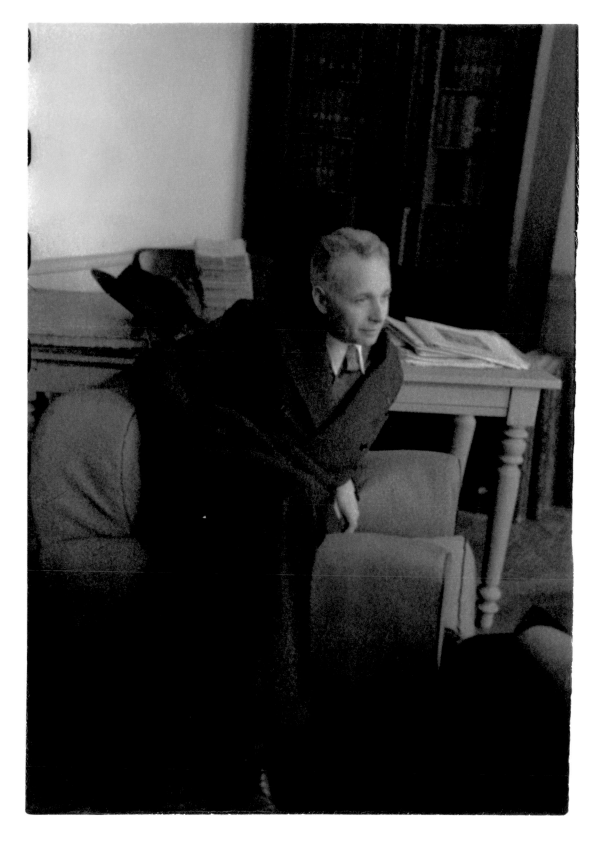

Louis Aragon

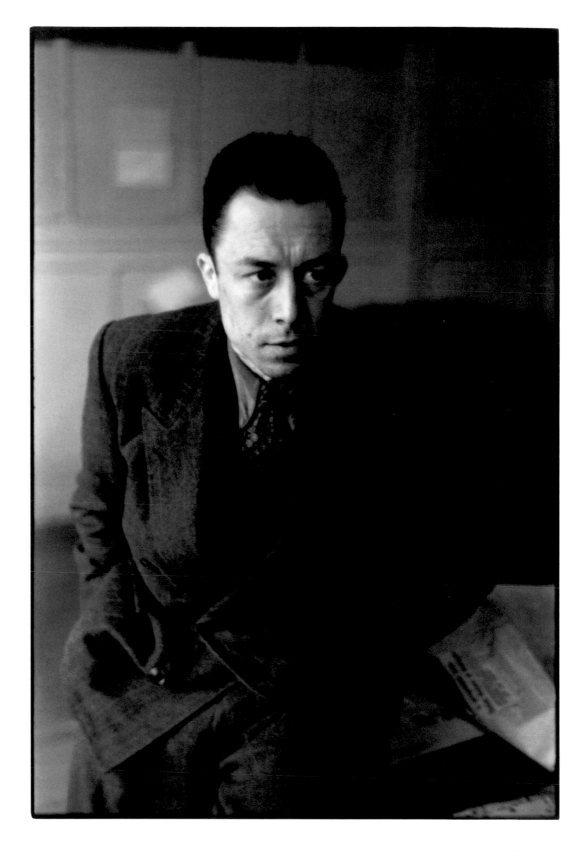

Albert Camus

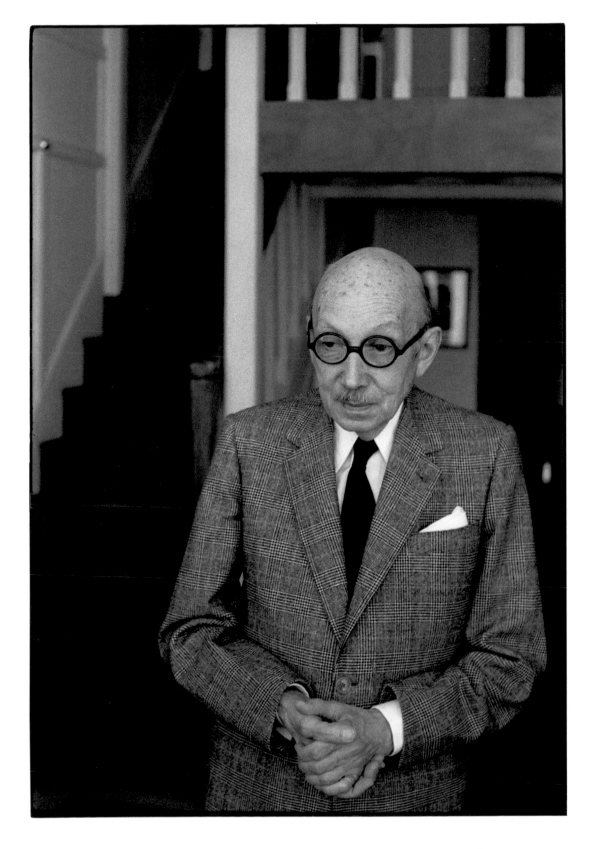

Pierre Jean Jouve

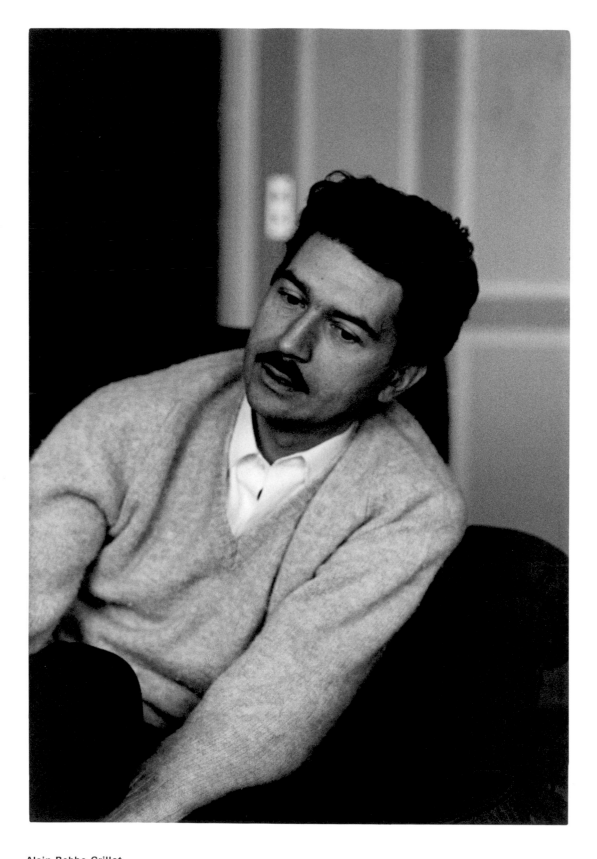

Alain Robbe-Grillet

90

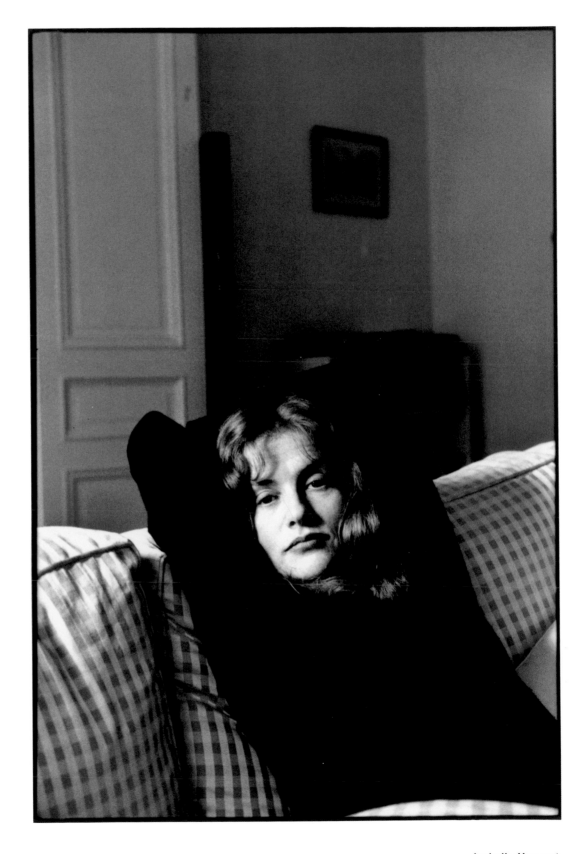

Isabelle Huppert

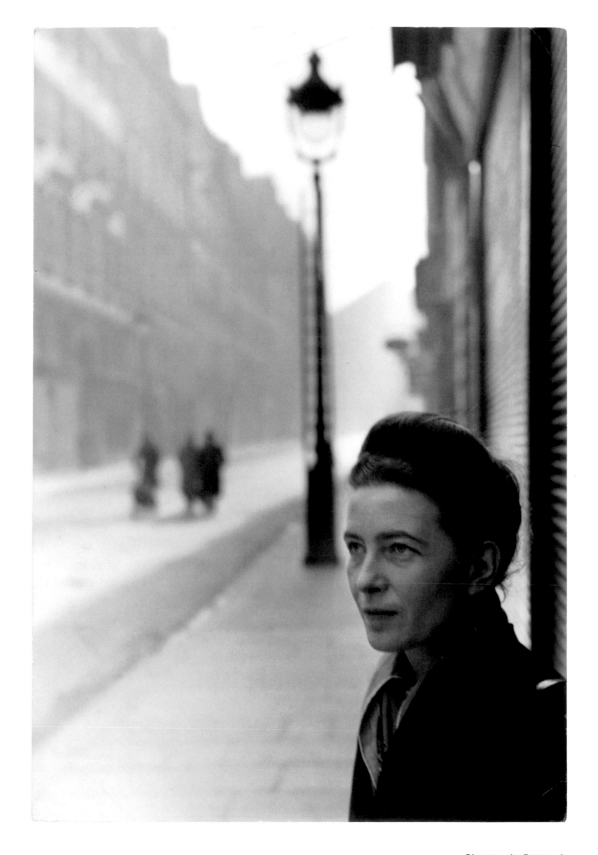

Simone de Beauvoir

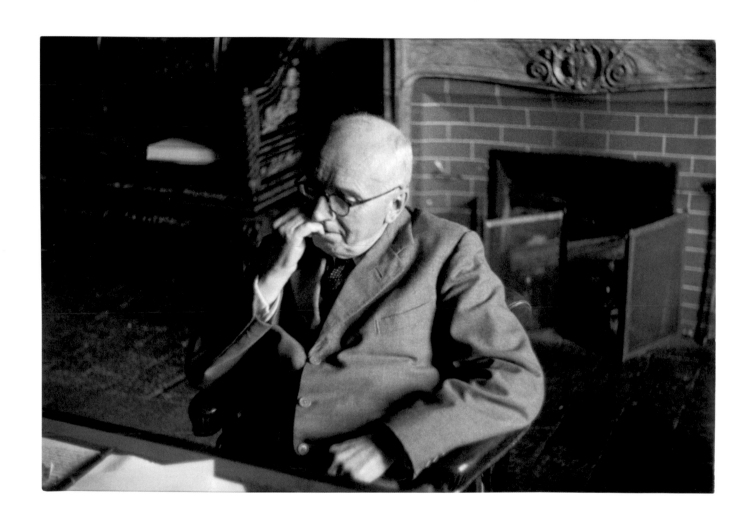

Paul Claudel

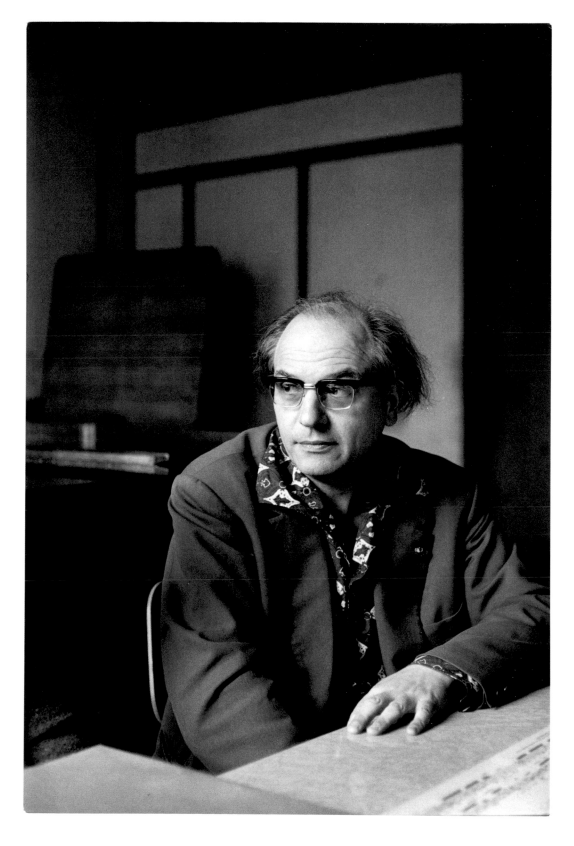

Olivier Messiaen

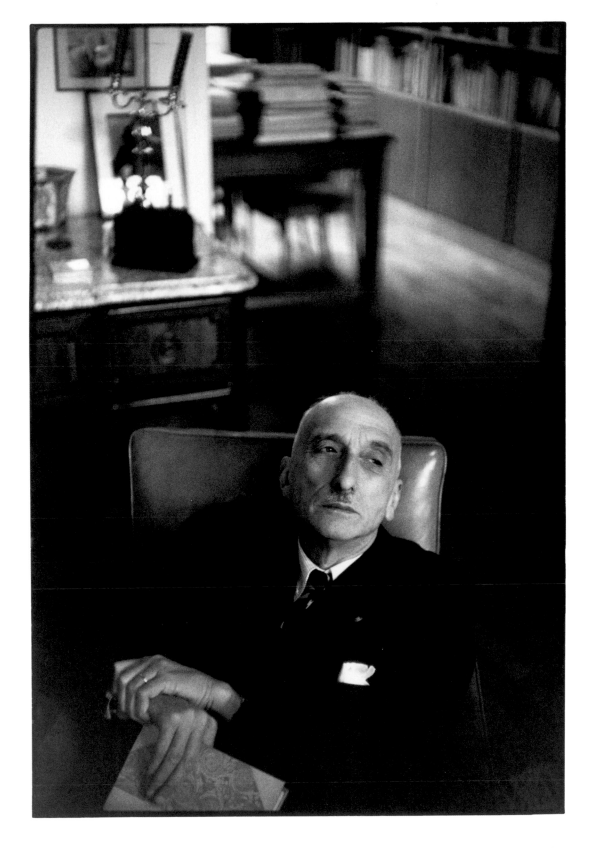

François Mauriac

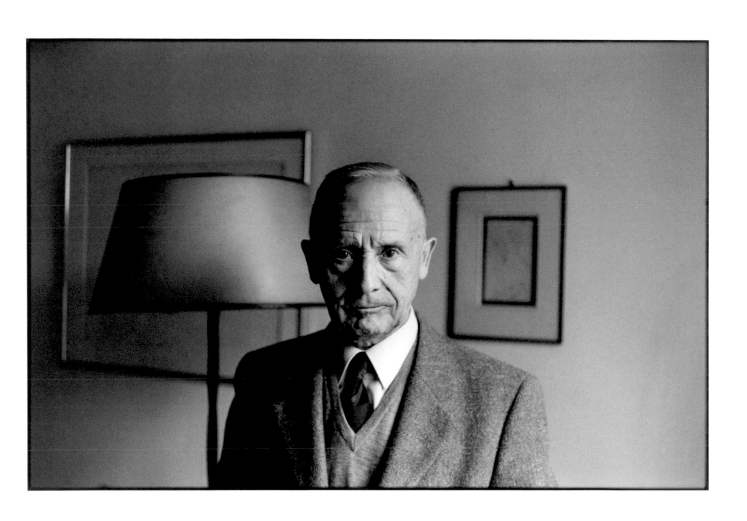

Julien Gracq

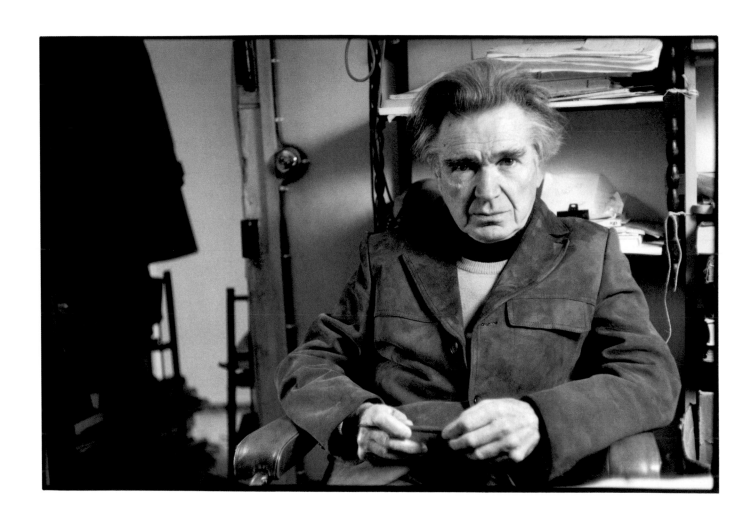

Emil Michel Cioran

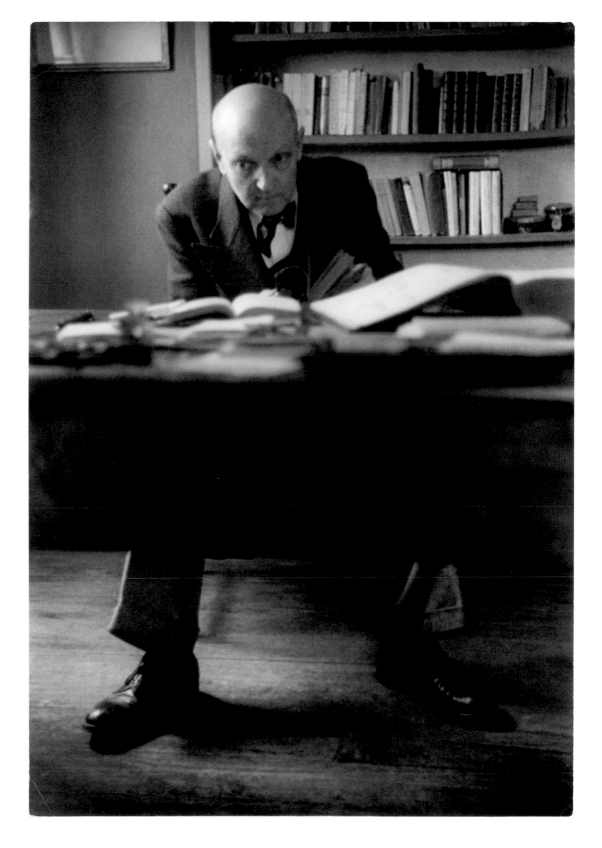

Georges Duhamel

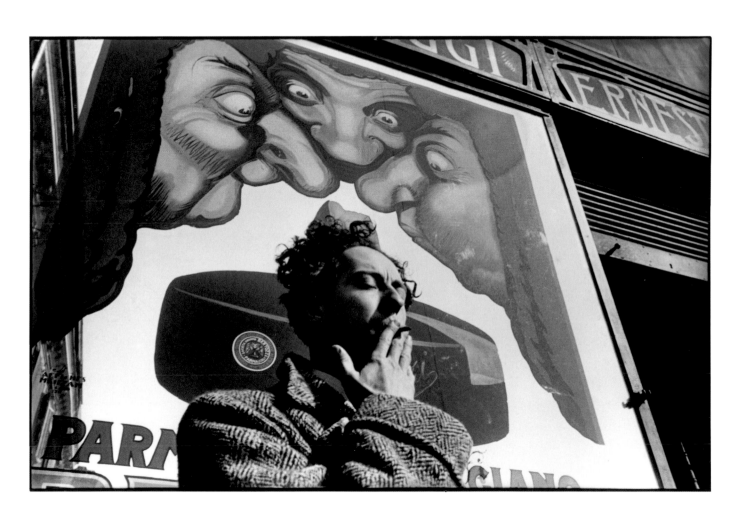

André Pieyre de Mandiargues

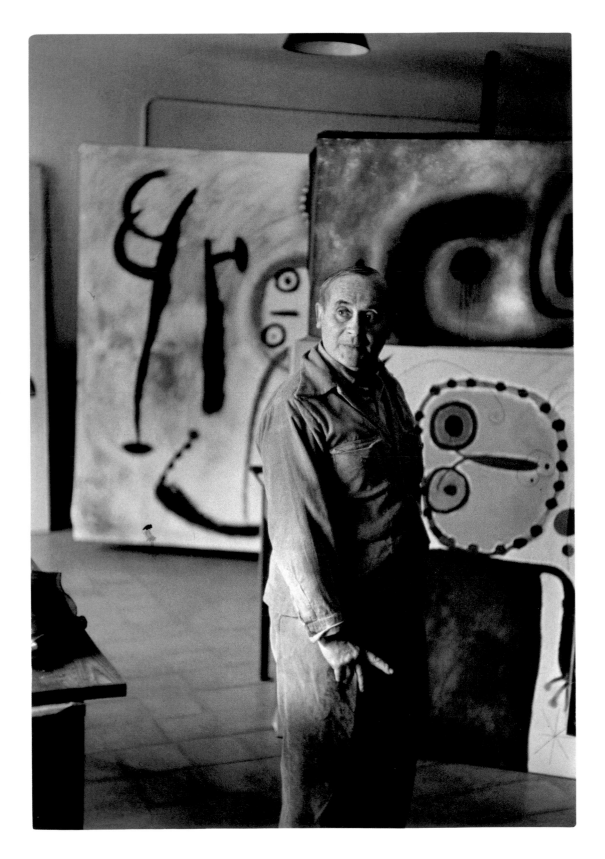

Joan Miró

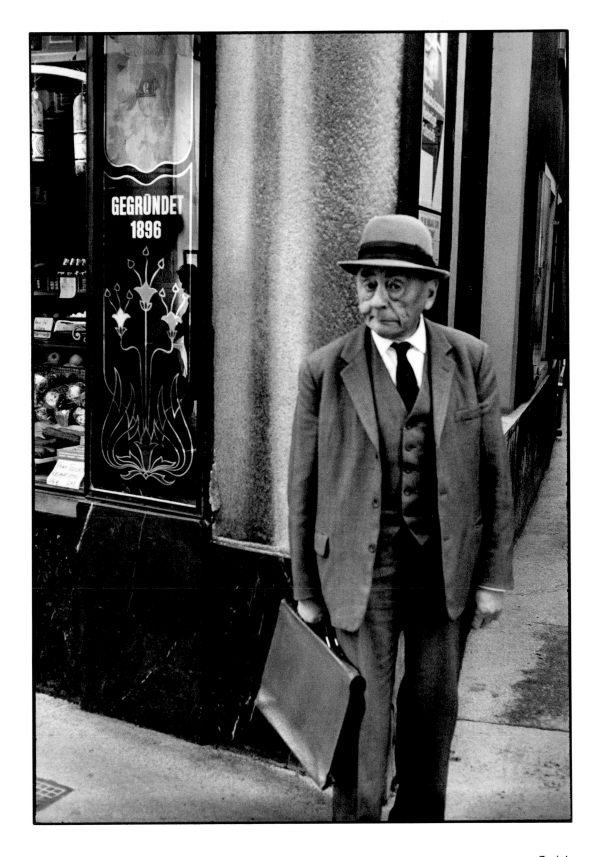

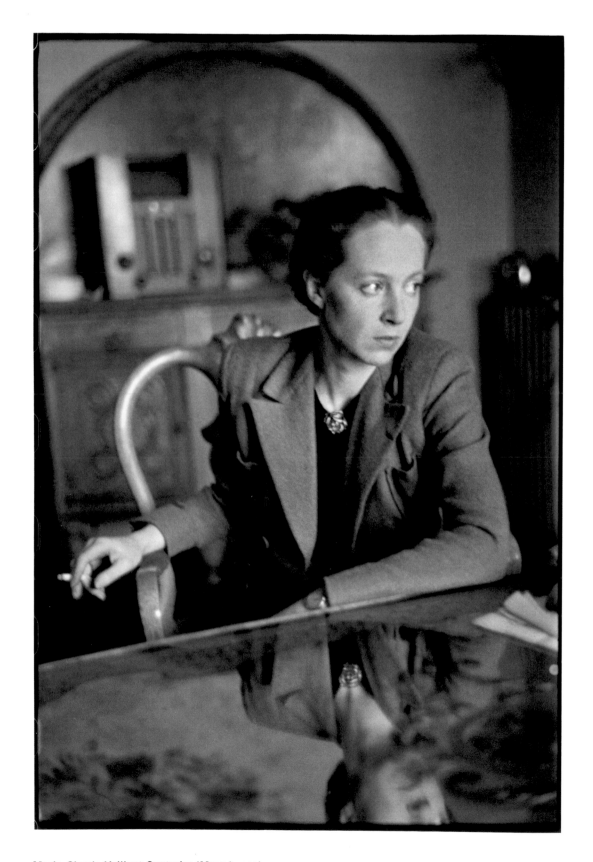

Marie-Claude Vaillant Couturier (Mara Lucas)

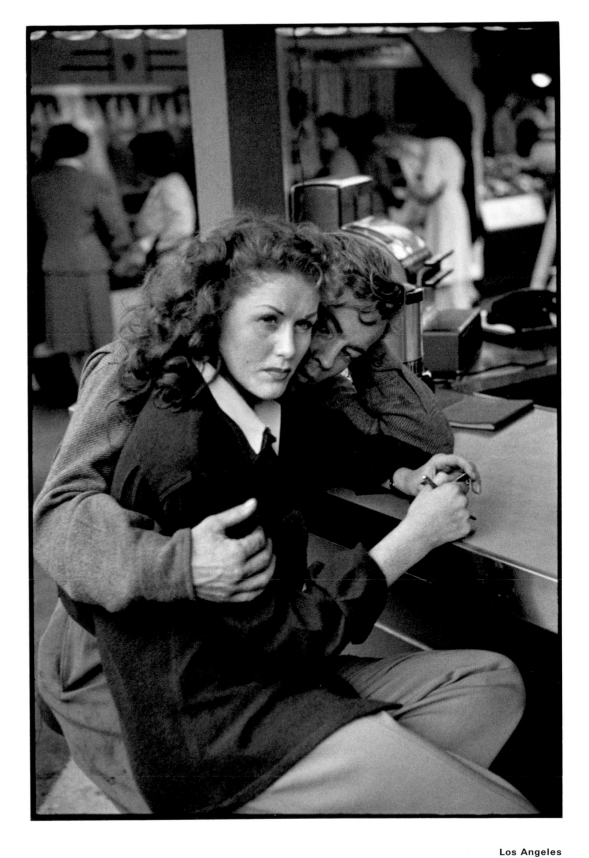

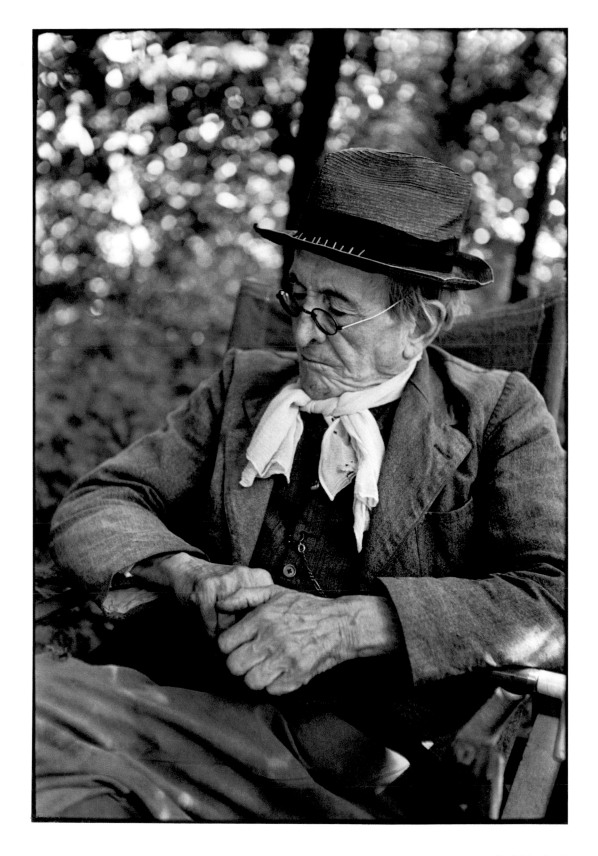

Paul Léautaud

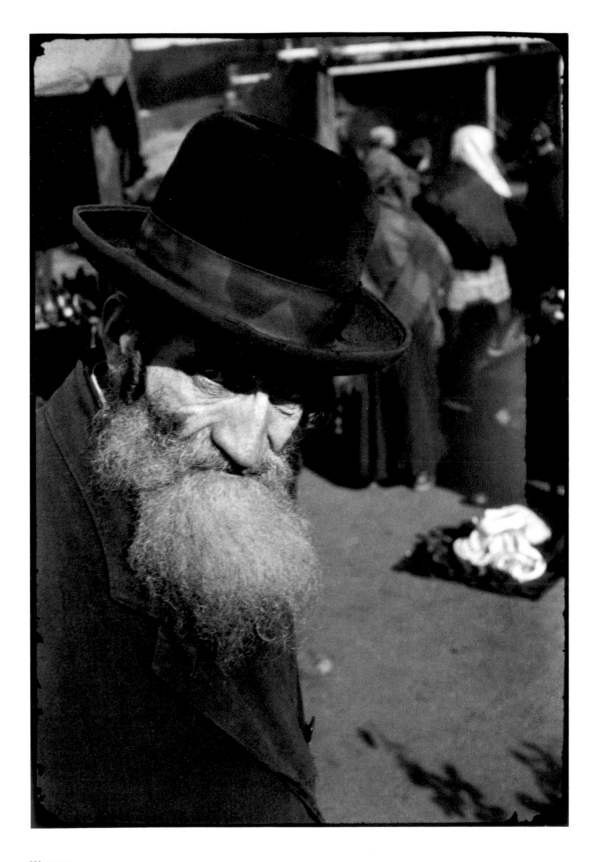

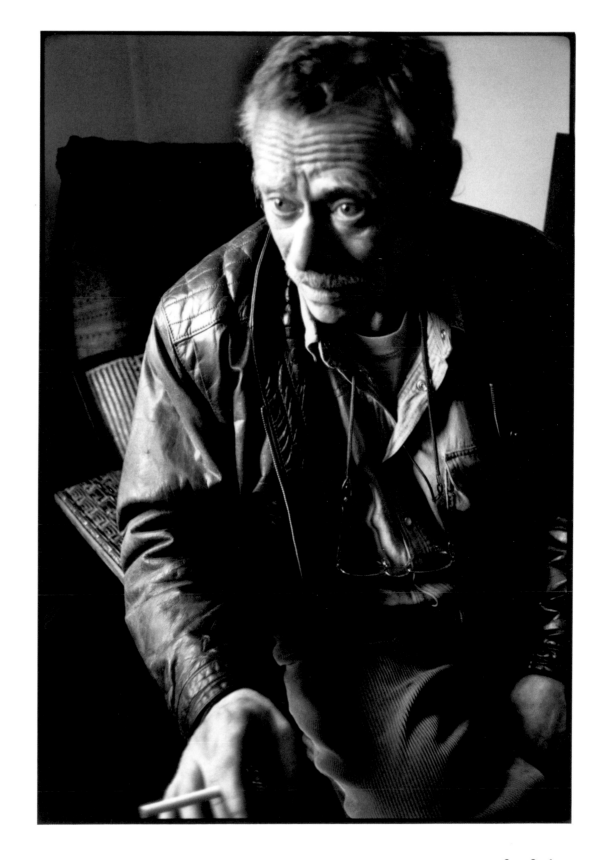

Sam Szafran

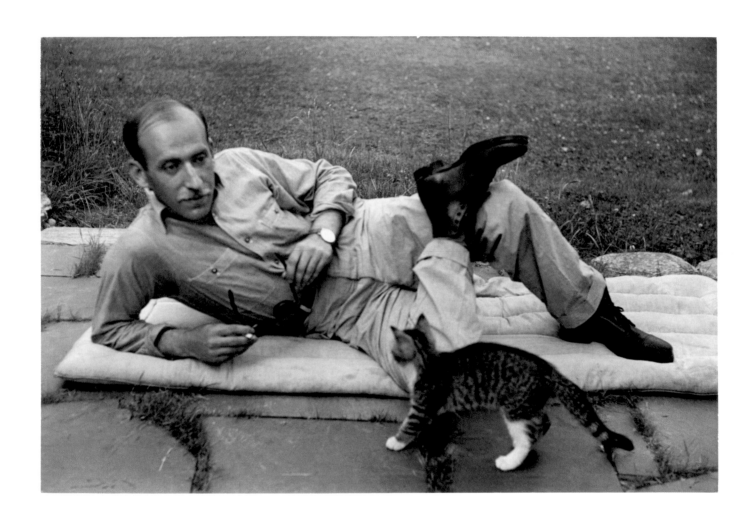

Saul Steinberg

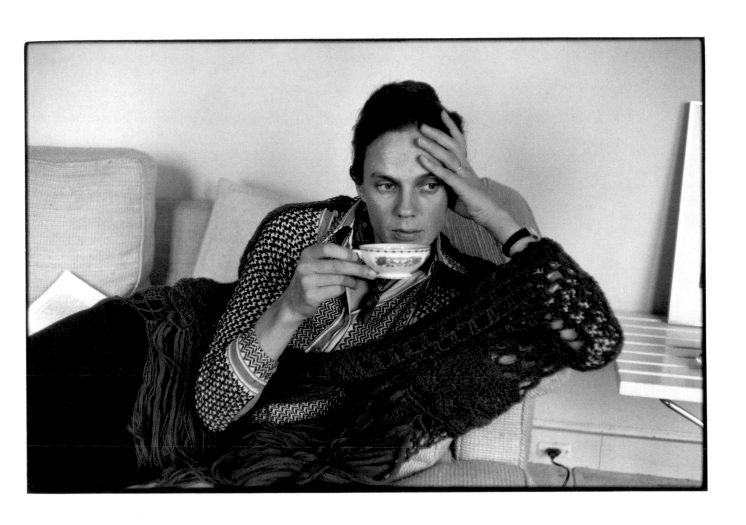

Martine Franck

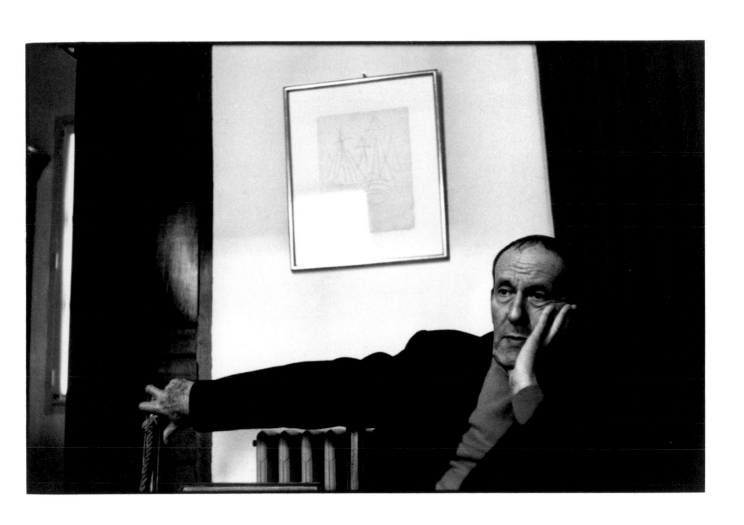

René Char

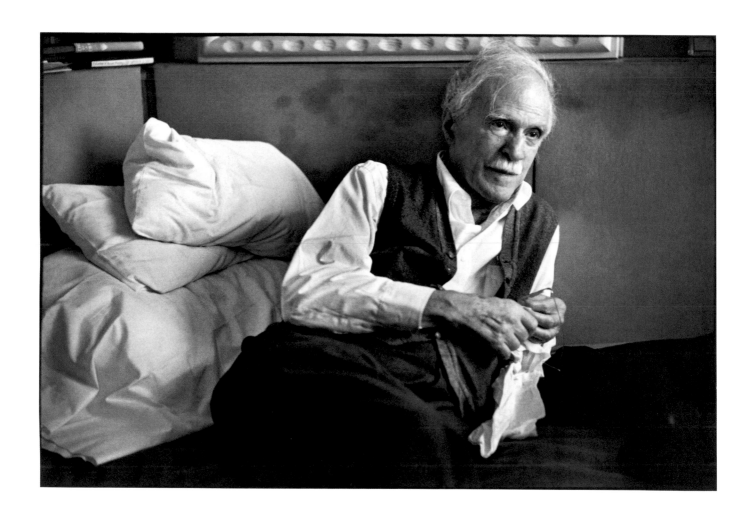

Alfred Stieglitz

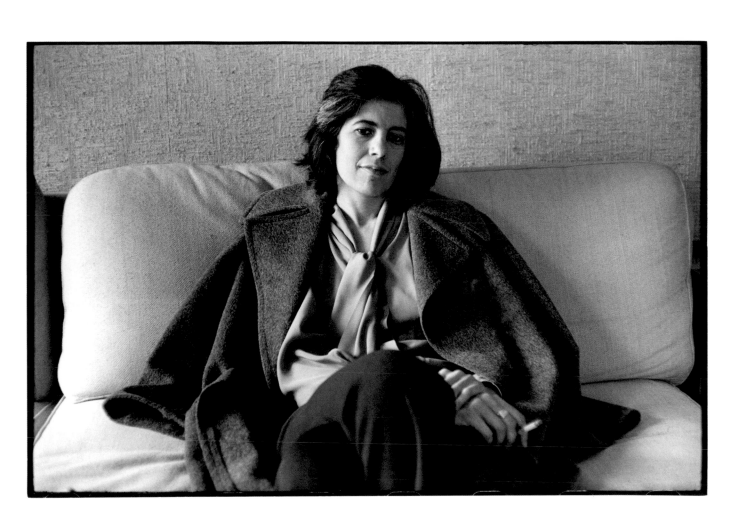

Susan Sontag

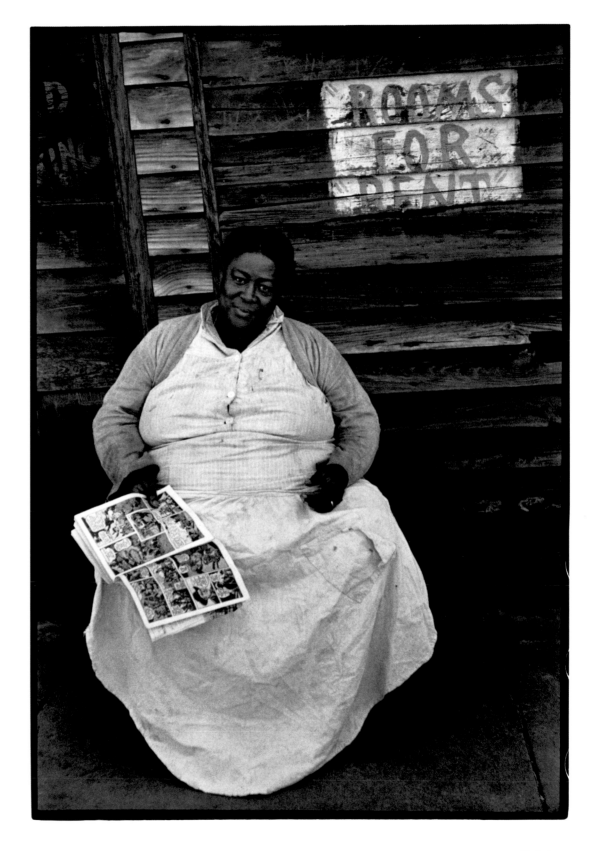

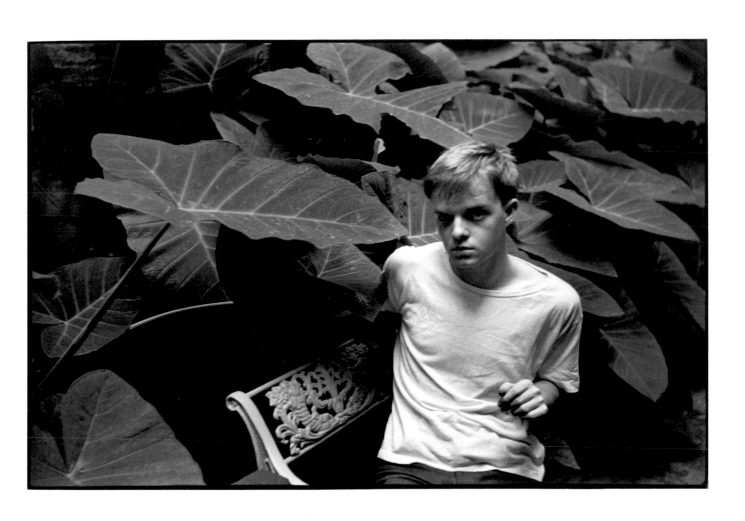

Truman Capote

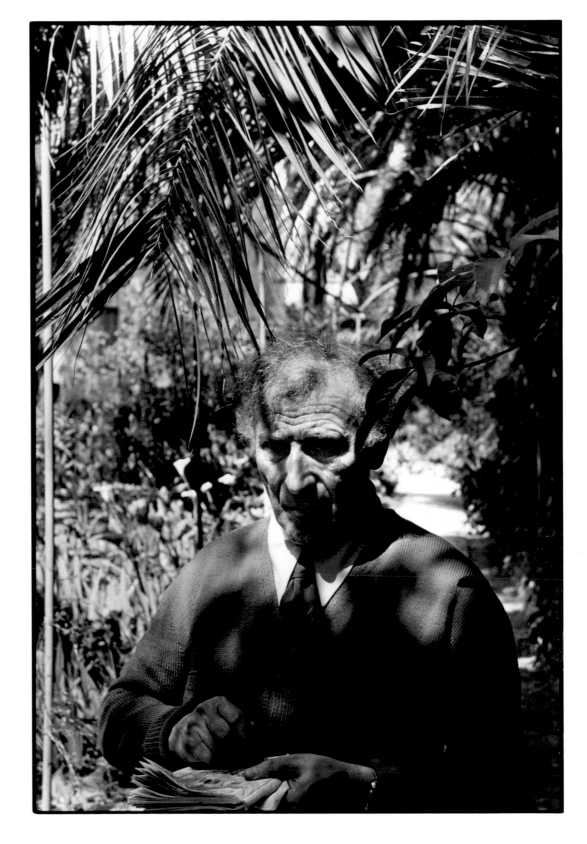

Marc Chagall

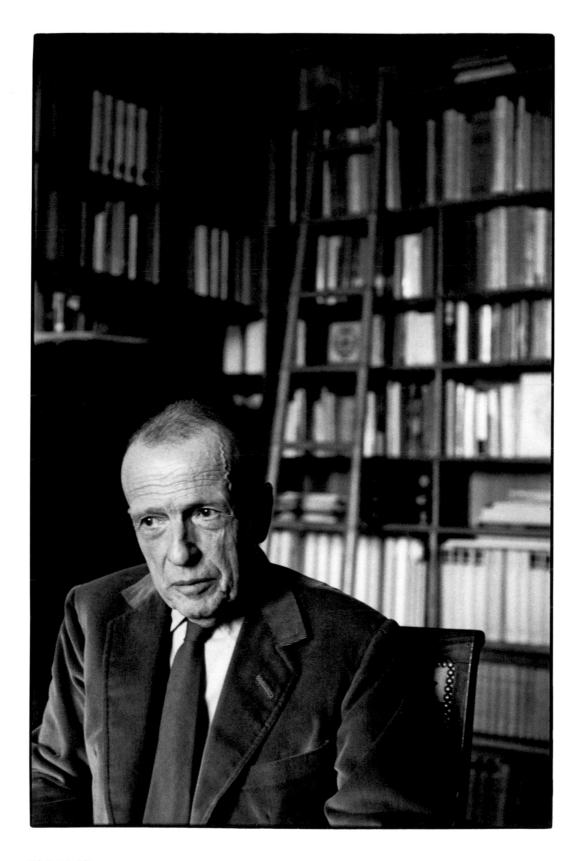

Michel Leiris

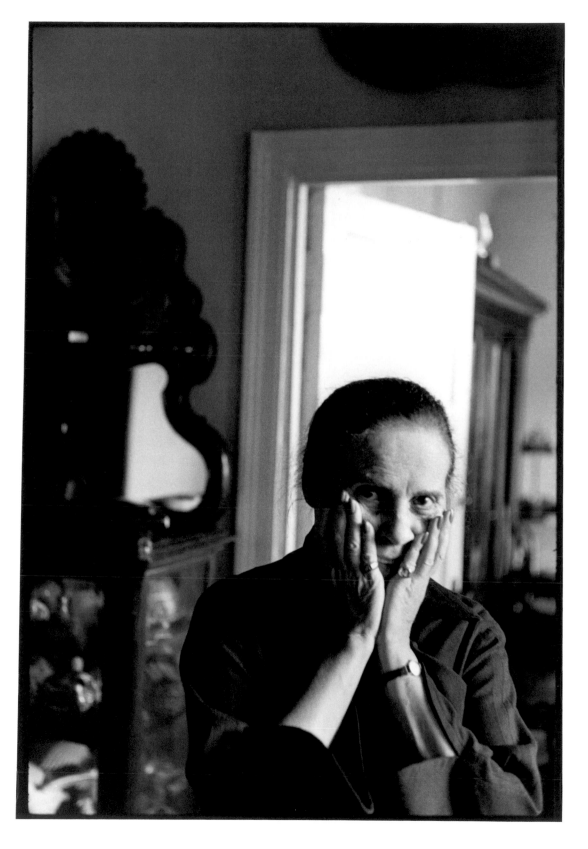

Lili Brik

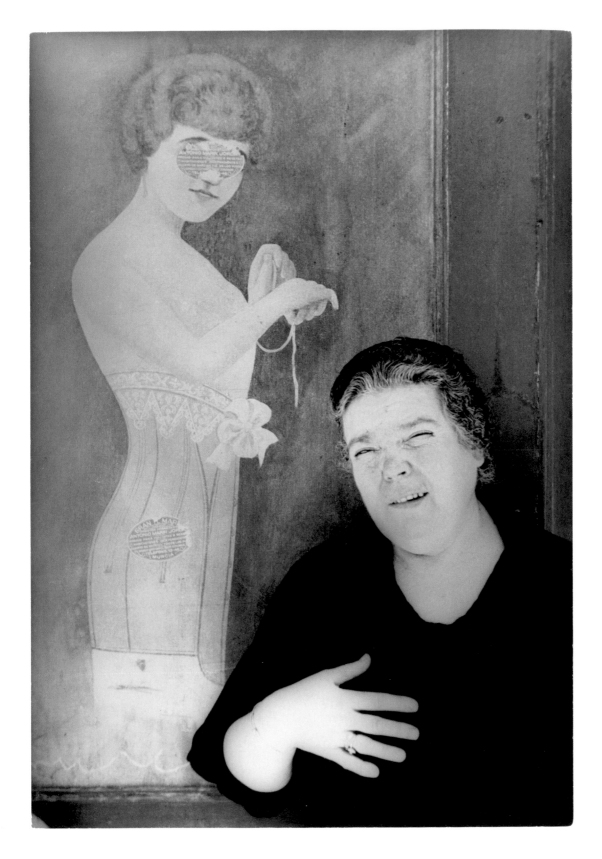

Cordoba

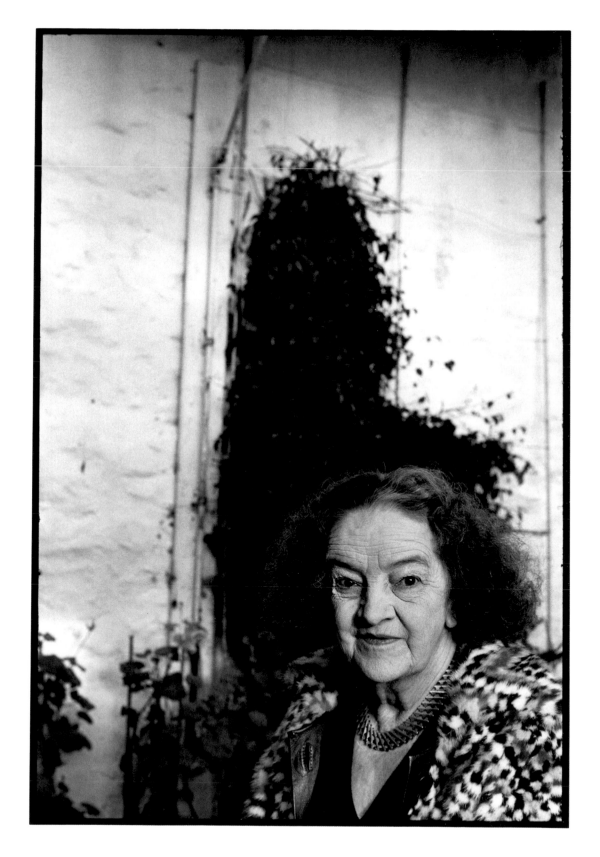

Barbara Hepworth

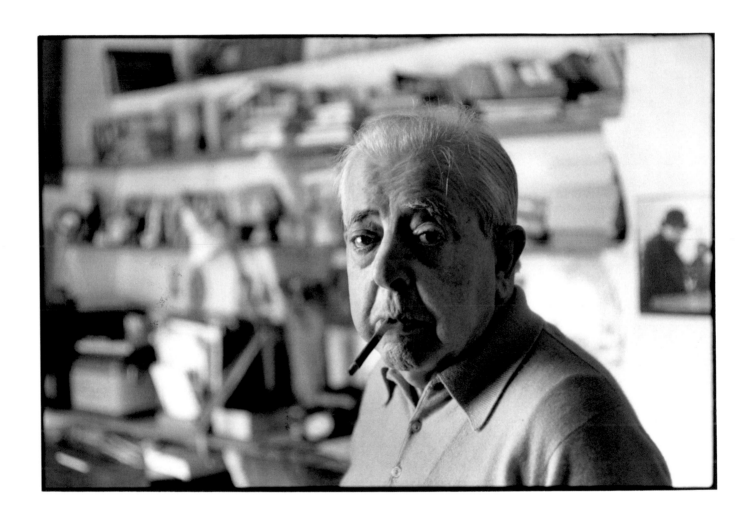

Jacques Prévert

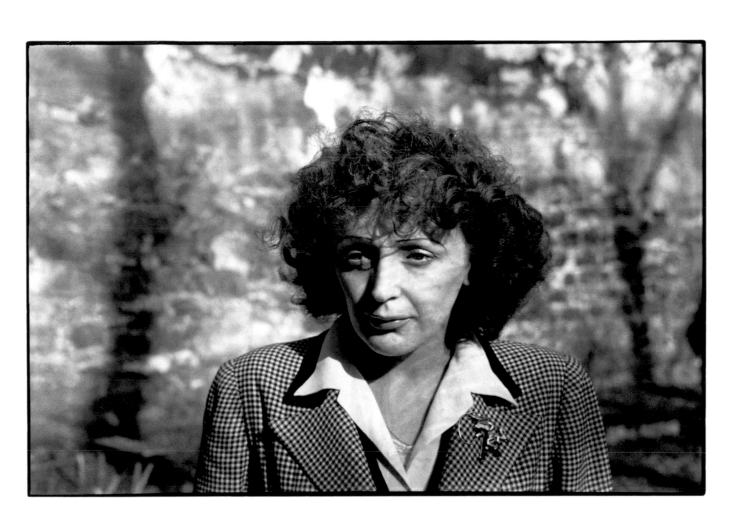

Edith Piaf

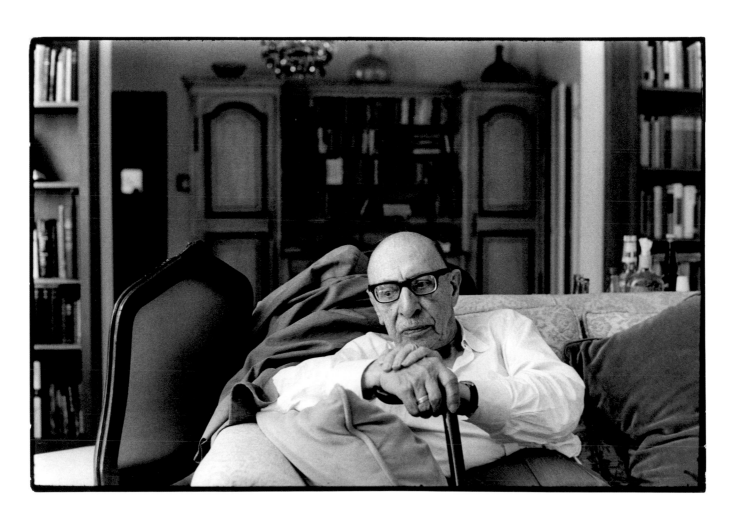

Igor Stravinsky

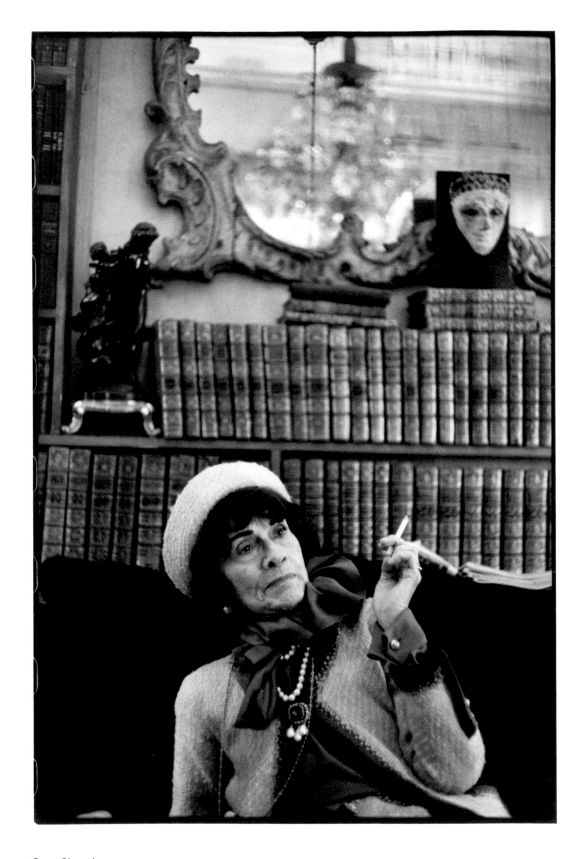

Coco Chanel

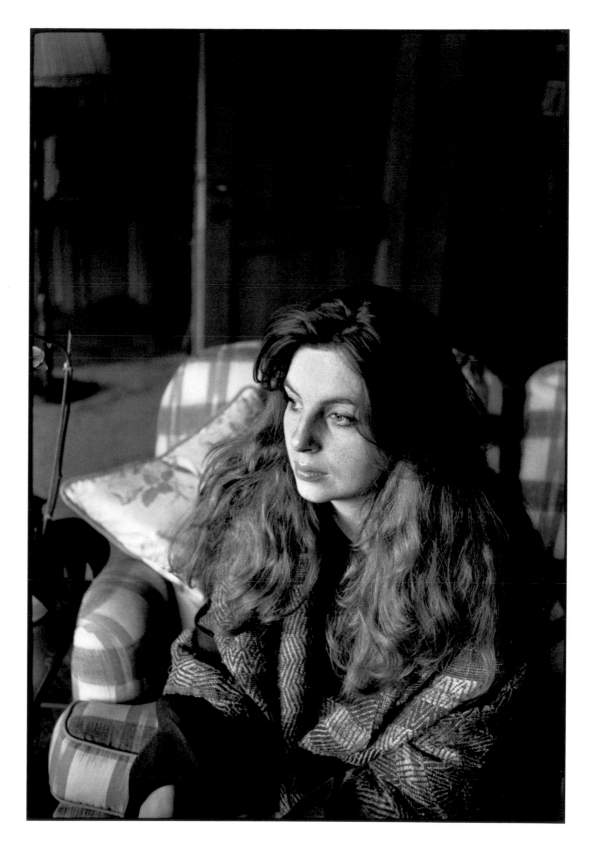

Mélanie Cartier-Bresson

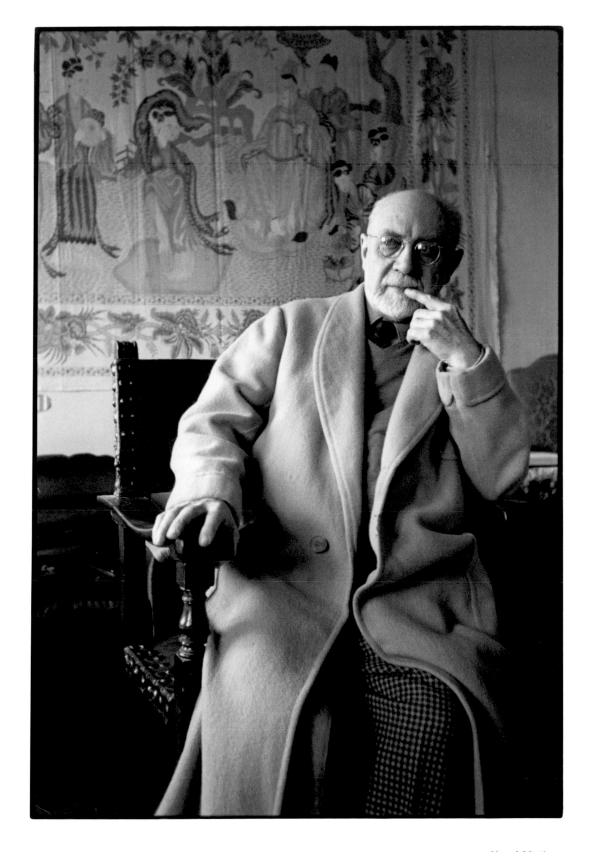

Henri Matisse

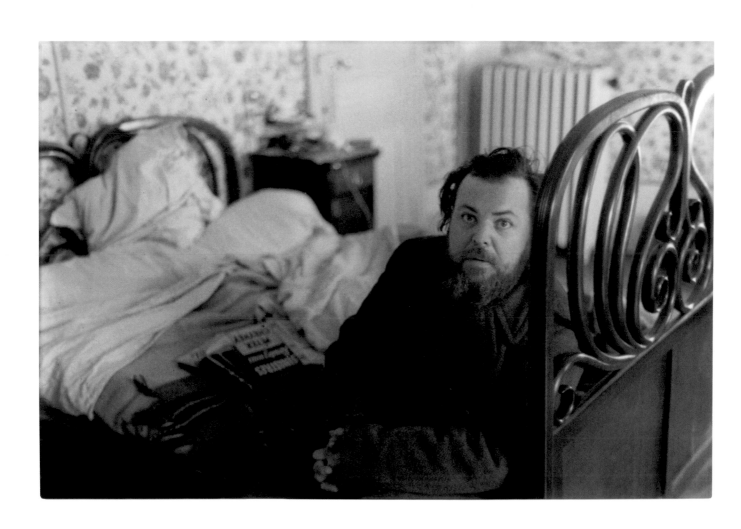

Christian Bérard

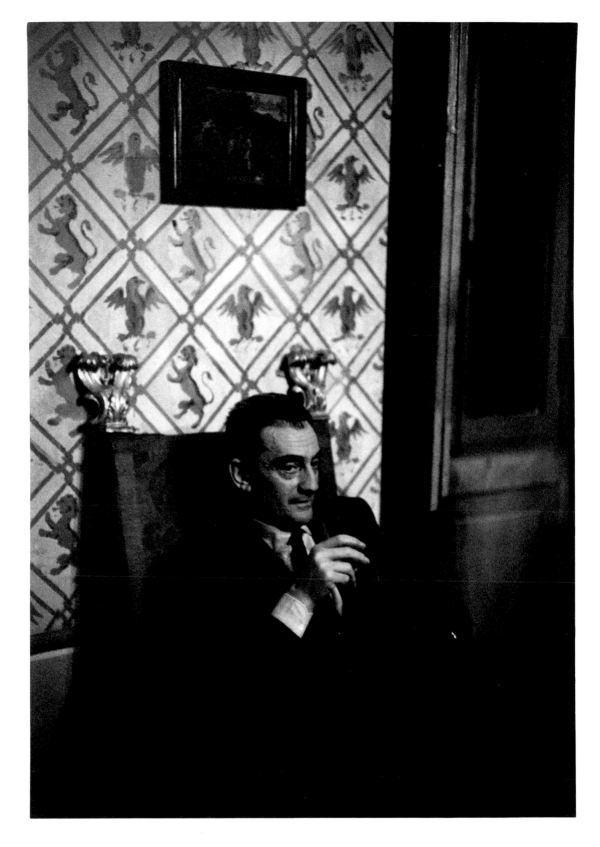

Luchino Visconti

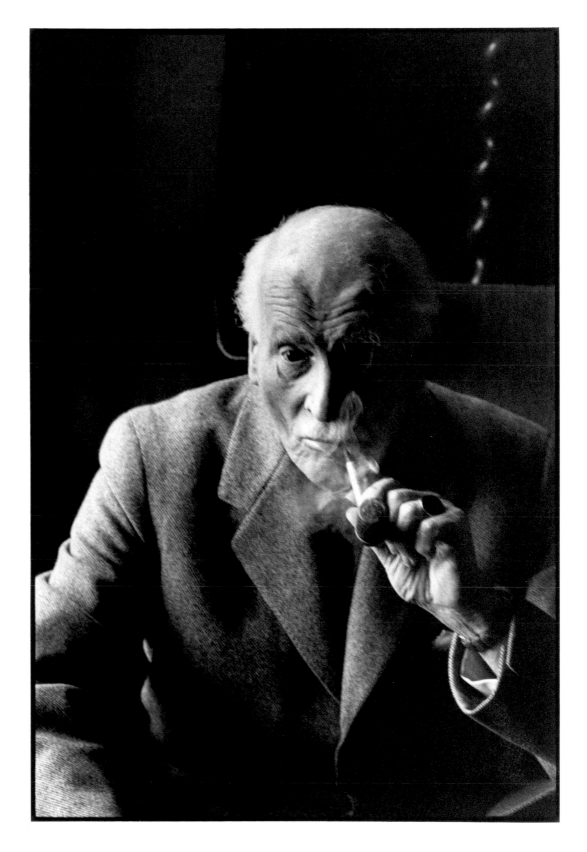

Carl Jung

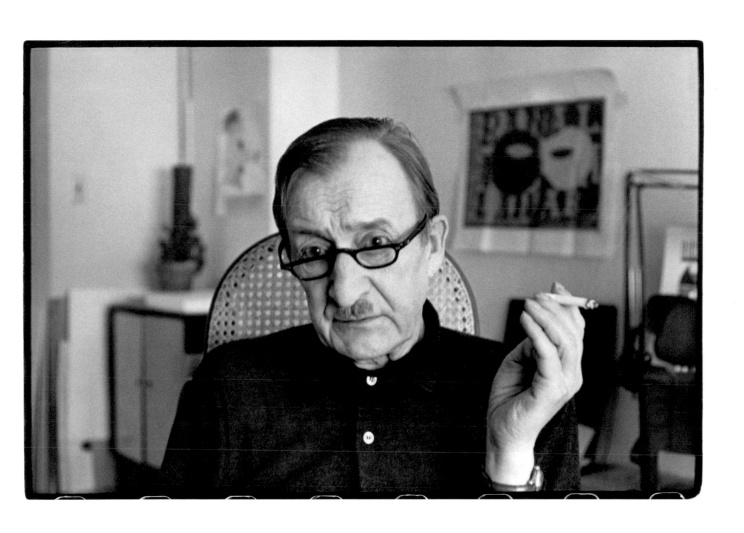

Alexey Brodovitch

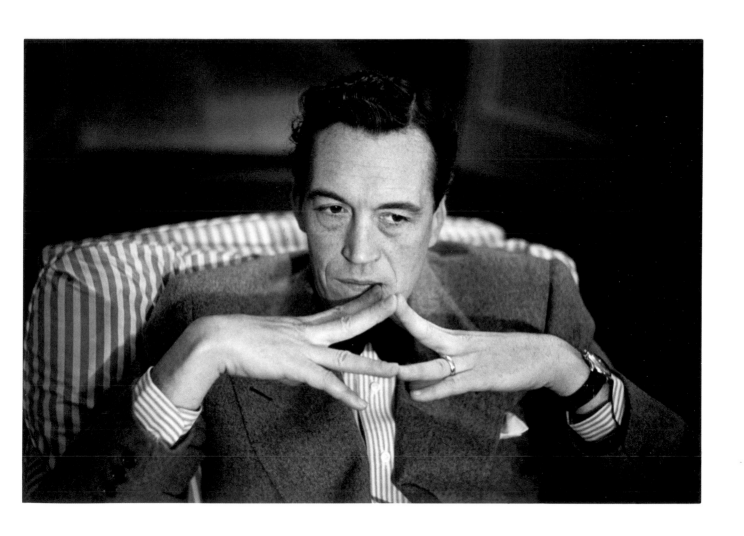

John Huston

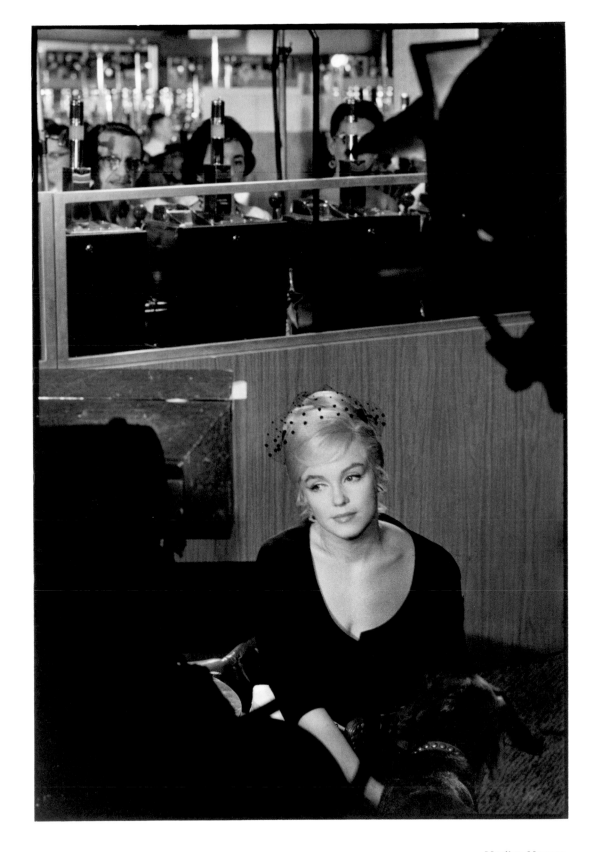

Marilyn Monroe

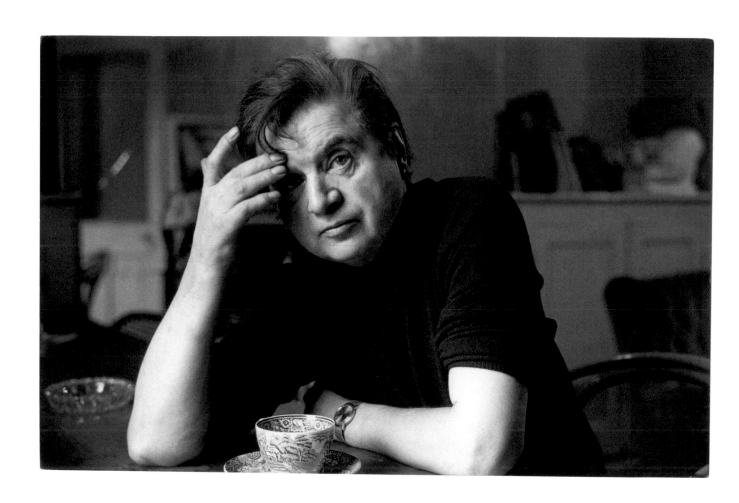

Francis Bacon

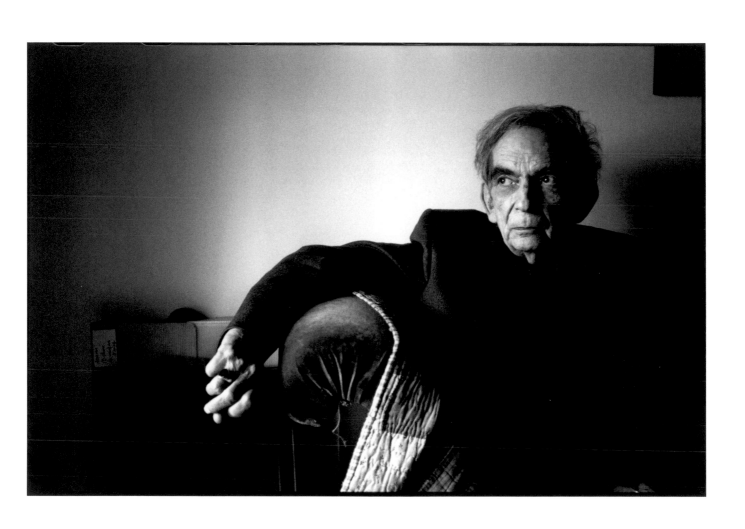

Louis-René des Forêts

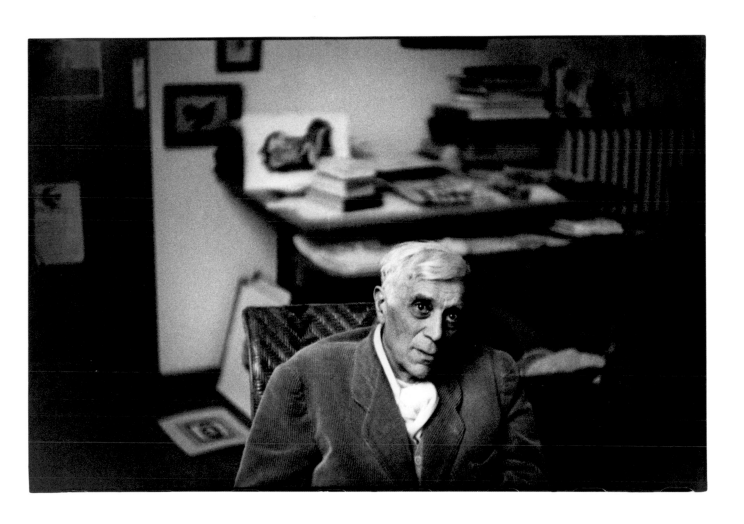

Georges Braque

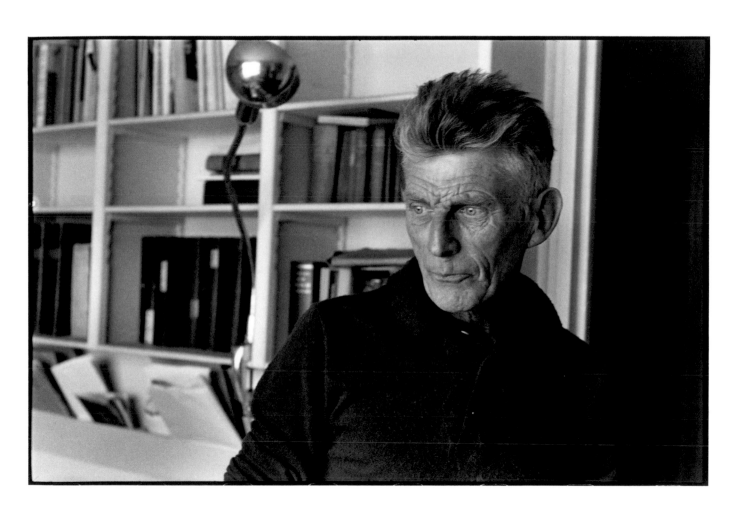

Samuel Beckett

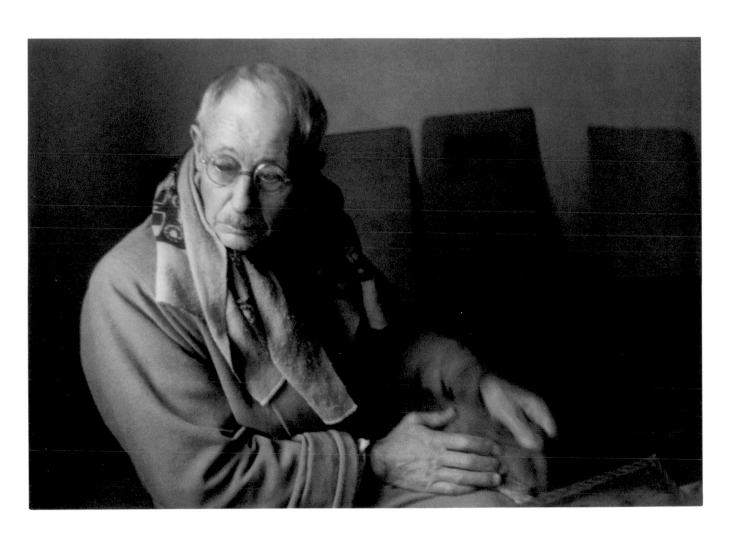

Pierre Bonnard

Page 12
'Madame ma Concierge'
Paris, 1945
Contemporary gelatin silver print
Print and image: 13.8 x 9.5 cm
HCB1945XXXW00XXXX//1

Page 23
Georges Rouault
At home, Paris, 1944
Contemporary gelatin silver print, signed
Print: 35.4 x 28.1 cm,
image: 34.9 x 23.8 cm
HCB1951007W00982/40C//1

Page 24
Christian Dior
Paris, 1945
Gelatin silver print, 1980s
Print: 29.6 x 20.1 cm,
image: 29.1 x 19.7 cm
HCB1951007W00989/17//2

Page 25
Jeanne Lanvin
Paris, 1945
Contemporary gelatin silver print, signed
Print and image: 34.6 x 23.1 cm
HCB1945001W0084CC//3

Page 27
Nicole Cartier-Bresson
France, 1944
Gelatin silver print, 1990s
Print: 18.2 x 24.1 cm,
image: 13.8 x 20.7 cm
HCB1944001W0083E//2

Page 28
Pierre Colle
Paris, 1932
Gelatin silver print, 1990s
Print: 25.7 x 19.4 cm,
image: 23.7 x 16.2 cm
HCB1932001W0068BC//2

Page 29
Mary Meerson and Krishna Riboud
At Krishna Riboud's home, France, 1967
Gelatin silver print, 1980s
Print: 26.1 x 19 cm,
image: 23.7 x 15.8 cm
HCB1967023W10993/15//1

Page 31
Alberto Giacometti
Stampa, Switzerland, 1961
Gelatin silver print, 2000s
Print: 24.1 x 18 cm,
image: 19.6 x 13.1 cm
HCB1961014W07210/80-81//2

Page 32
Arthur Honegger
France, c. 1945
Contemporary gelatin silver print
Print and image: 16.5 x 11.9 cm
HCB1951007W00988/24//1

Page 33
Elsa Triolet
Paris, 1945
Gelatin silver print, 1970s
Print: 30.1 x 20.4,
image: 29.9 x 20.1 cm
HCB1945001W0083B//3

Page 35
José Bergamin
Paris, 1969
Contemporary gelatin silver print
Print: 24.9 x 16.7 cm,
image: 24.5 x 16.4 cm
HCB1969042W12164/26//1

Page 36
René Etiemble
France, 1963
Gelatin silver print, 1980s
Print: 27.9 x 18.8,
image: 25.1 x 16.7 cm
HCB1963012W08722/31//1

Page 37
Jawaharlal Nehru
New Delhi, India, 1948
Contemporary gelatin silver print
Print and image: 25.7 x 17.4 cm
HCB1947007W00080/13//1

Page 39
Egypt
Egypt, 1950
Gelatin silver print, 2003
Print: 23.9 x 30.4 cm,
image: 18.5 x 27.6 cm
HCB1950005W00886/04//1

Page 41
Koen Yamaguchi
Kyoto, 1965
Gelatin silver print, 1980s
Print: 35.4 x 28 cm,
image: 25.1 x 17 cm
HCB1965007W09877/11C//2

Page 43
Léonor Fini
France, 1946
Contemporary gelatin silver print
Print and image: 12 x 8 cm
HCB1946XXXW00071/36A//1

Page 45
Irène and Frédéric Joliot-Curie
At home, Paris, c. 1944
Contemporary gelatin silver print
Print and image: 34.1 x 23.5 cm
HCB1944001W0084AC//8

Page 46
Cracow
Poland, 1931
Gelatin silver print, 1970s
Print: 25.4 x 20.1 cm,
image: 24 x 16 cm
HCB1931001W0191C//1

Page 47
Jewish ghetto, Warsaw
Poland, 1931
Gelatin silver print, 2005
Print: 24.3 x 18.7 cm,
image: 22.6 x 15.2 cm
HCB1931001W0174D//1

Page 49
Mexico
1934
Gelatin silver print, signed, 1980s
Print: 40.7 x 30.3 cm,
image: 35.6 x 23.8 cm
HCB1934003W00001C//5

Page 51
Colette and her housekeeper
At home, Paris, 1952
Contemporary gelatin silver print
Print: 30 x 20.8 cm,
image: 29.9 x 19.4 cm
HCB1952018W01546/12AC//4

Page 53
Ezra Pound
Venice, 1971
Gelatin silver print, 1990s
Print: 40.5 x 30.5 cm,
image: 35.7 x 24 cm
HCB1971005W12332/08AC//2

Page 54
Igor Markevitch
Paris, 1964
Gelatin silver print, 1970s
Print and image: 31.7 x 21.1 cm
HCB1964009W09192/25//1

Page 55
Boris Kochno
At home, Paris, 1938
Contemporary gelatin silver print
Print and image: 23.8 x 15.8 cm
HCB1938XXXXWXXXXX/XX//2

Page 57
André Breton
At home, rue Fontaine, Paris, 1961
Gelatin silver print, 2001
Print: 40.3 x 30.1 cm,
image: 37.3 x 24.8 cm
HCB1961014W07203/81C//1

Page 59
Louis Pons
At home, Paris, 1999
Contemporary gelatin silver print
Print: 23.9 x 30.4 cm,
image: 18.6 x 27.8 cm
HCB1999001W14964/25-25A//1

Page 61
Marcel Duchamp
Paris, 1968
Contemporary gelatin silver print
Print and image: 19.7 x 29.1 cm
HCB1968007W11090/09//1

Page 62
Roberto Rossellini
Campagna, Italy, 1960
Gelatin silver print, 1990s
Print: 30.5 x 23.9 cm,
image: 27.7 x 18.4 cm
HCB1960011W06257/40//1

Page 63
Alexander Calder
At home, Saché, France, 1970
Gelatin silver print, 1980s
Print: 30.3 x 23.9 cm,
image: 29.8 x 19.7 cm
HCB1970006W12231/33AC//2

Page 64
William Faulkner
At home, Oxford, Mississippi, 1947
Contemporary gelatin silver print
Print and image: 18 x 12.1 cm
HCB1946006W00004/05C//3

Page 65
Carson McCullers
New York, 1946
Gelatin silver print, 1980s
Print: 27 x 18.7 cm,
image: 24.7 x 16.4 cm
HCB1946053W00002/16//1

Page 67
Arthur Miller
USA, 1961
Contemporary gelatin silver print
Print and image: 20.1 x 29.9 cm
HCB1961006W07020/24//2

Page 68
Robert Flaherty
On the set of *Louisiana Story*,
USA, 1947
Gelatin silver print, 1980s
Print: 35.5 x 27.8 cm,
image: 25.3 x 16.9 cm
HCB1946009W00001/39C//4

Page 69
**Joe the trumpeter and
his wife May**
New York, 1935
Gelatin silver print, signed, 1979
Print: 40 x 30 cm,
image: 35.5 x 24 cm
HCB1935001W0229EC//1

Page 71
Martin Luther King
Ebenezer Baptist Church, Atlanta,
Georgia, 1961
Contemporary gelatin silver print
Print: 26 x 17.4 cm,
image: 24.5 x 16.2 cm
HCB1961006W06970/78//2

Page 72
Pablo Neruda
Paris, 1971
Contemporary gelatin silver print
Print: 30.1 x 23.8 cm,
image: 24.6 x 16.3 cm
HCB1971014W12548/06//1

Page 73
Robert Oppenheimer
USA, 1958
Contemporary gelatin silver print,
signed
Print: 40 x 30.1 cm,
image: 39 x 26.2 cm
HCB1958005W04536/36C//2

Page 74
Avigdor Arikha
In his studio, Paris, 1971
Gelatin silver print, 1980s
Print: 27.5 x 19 cm,
image: 25 x 16.4 cm
HCB1971014W12553/11C//2

Page 75
Beaumont Newhall
New York, 1946
Contemporary gelatin silver print
Print and image: 35.3 x 23.8 cm
HCB1946053W00007/29//1

Page 77
Roland Barthes
Paris, 1963
Contemporary gelatin silver print
Print and image: 29.7 x 19.9 cm
HCB1963012W08718/05//1

Page 78
Jean Genet
Café Le Flore, Paris, 1964
Gelatin silver print, signed, 1979
Print: 30 x 40 cm,
image: 24 x 35.5 cm
HCB1963012W08719/39AC//1

Page 79
Jean-Marie Le Clézio and his wife
Paris, 1965
Contemporary gelatin silver print,
signed
Print: 30 x 39.8 cm,
image: 26.2 x 38.9 cm
HCB1965002W09325/14//2

Page 81
Paris
Avenue du Maine, Paris, 1932
Gelatin silver print, signed, 1980s
Print: 30.5 x 40.5 cm,
image: 23.9 x 35.6 cm
HCB1932001W0070EC//4

Page 83
**Jean-Paul Sartre and Fernand
Pouillon**
Pont des Arts, Paris, 1946
Gelatin silver print, signed, 1980s
Print: 40.6 x 30.3 cm,
image: 35.7 x 23.9 cm
HCB1946055W00107/XC//3

Page 84
Paul Eluard
At home, Paris, 1944
Contemporary gelatin silver print
Print and image: 28.4 x 18.1 cm
HCB1944002W00036/19//2

Page 85
Louis Aragon
At home, Paris, 1945
Contemporary gelatin silver print
Print and image: 12 x 8 cm
HCB1945002W00051/06//2

Page 87
Albert Camus
Paris, 1945
Gelatin silver print, 1980s
Print: 25.5 x 20.2 cm,
image: 23.7 x 15.8 cm
HCB1945002W00106/18-18A//1

Page 89
Pierre Jean Jouve
France, 1964
Contemporary gelatin silver print
Print and image: 30.1 x 20.3 cm
HCB1964003W09022/18C//4

Page 90
Alain Robbe-Grillet
France, 1961
Contemporary gelatin silver print
Print and image: 29.6 x 19.8 cm
HCB1961010W07142/62//1

Page 91
Isabelle Huppert
Paris, 1994
Contemporary gelatin silver print
Print: 24 x 17.8 cm,
image: 21.8 x 14.4 cm
HCB1994006W14886/10A11//1

Page 93
Simone de Beauvoir
Rue Schoelcher, Paris, 1947
Gelatin silver print, 1960s
Print and image: 25.3 x 17 cm
HCB1947013W0095D//1

Page 94
Paul Claudel
France, *c.* 1945
Gelatin silver print, 1970s
Print: 21 x 30.4 cm,
image: 20.2 x 29.9 cm
HCB1951007W00970/13A//2

Page 95
Olivier Messiaen
France, 1962
Contemporary gelatin silver print
Print and image: 29.6 x 19.7 cm
HCB1964003W09014/12//2

Page 97
François Mauriac
At home, Paris, 1952
Gelatin silver print, 1970s
Print: 30 x 20 cm,
image: 29.6 x 19.6 cm
HCB1952018W01555/22AC//5

Page 99
Julien Gracq
At home, Paris, 1984
Gelatin silver print, signed, 2001
Print: 30.1 x 40.3 cm,
image: 25 x 37.5 cm
HCB1984001W14456/13AC//1

157

Page 131
Igor Stravinsky
In his studio, California, 1967
Contemporary gelatin silver print
Print: 20.1 x 29.5 cm,
image: 19.5 x 29 cm
HCB1967017W10890/26C//2

Page 132
Coco Chanel
Paris, 1964
Gelatin silver print, 1970s
Print: 25.5 x 20.1 cm,
image: 23.8 x 15.8 cm
HCB1964003W08990/26C//2

Page 133
Mélanie Cartier-Bresson
Paris, 1999
Gelatin silver print, 2005
Print: 30 x 24.1 cm,
image: 26.6 x 17.8 cm
HCB1999001W14970//1

Page 135
Henri Matisse
At home, Villa Le Rêve, Vence,
France, *c.* 1944
Gelatin silver print, signed, 1970s
Print: 24.8 x 16.5 cm,
image: 24.5 x 16.2 cm
HCB1951007W00966/29A30//2

Page 136
Christian Bérard
Saint-Mandé, France, 1946
Gelatin silver print, 1950s
Print and image: 15.7 x 22.9 cm
HCB1946054W0087D//3

Page 137
Luchino Visconti
Umbria, Italy, 1961
Contemporary gelatin silver print
Print and image: 30.1 x 20.5 cm
HCB1961014W07216/42//1

Page 139
Carl Gustav Jung
Küsnacht, Switzerland, 1959
Gelatin silver print, 1990s
Print: 25.7 x 19.4 cm,
image: 24 x 16 cm
HCB1959038W05950/64//1

Page 141
Alexey Brodovitch
New York, 1962
Contemporary gelatin silver print,
signed
Print: 30 x 39.8 cm,
image: 26 x 39 cm
HCB1962001W07588/23//2

Page 143
John Huston
New York, 1947
Gelatin silver print, 1970s
Print and image: 17.1 x 24.8 cm
HCB1946053W00036/36//1

Page 145
Marilyn Monroe
On the set of *The Misfits*, USA,
1960
Gelatin silver print, 1980s
Print: 25.9 x 19.1 cm,
image: 23.6 x 15.7 cm
HCB1960014W06357/19AC//1

Page 146
Francis Bacon
London, 1971
Contemporary gelatin silver print
Print and image: 15.8 x 24.4 cm
HCB1971004W12321/00A//1

Page 147
Louis-René des Forêts
Paris, 1995
Contemporary gelatin silver print
Print: 23.8 x 30.3 cm,
image: 18.3 x 27.6 cm
HCB1995001W14907/05A//1

Page 149
Georges Braque
Paris, 1958
Gelatin silver print, 1970s
Print: 16.8 x 24.9 cm,
image: 16.5 x 24.5 cm
HCB1958020W05069/08//2

Page 151
Samuel Beckett
At home, Paris, 1964
Gelatin silver print, 1970s
Print: 20 x 29.6 cm,
image: 18.6 x 28.1 cm
HCB1964003W09012/36C//4

Page 153
Pierre Bonnard
At home, Le Cannet, France, 1943
Contemporary gelatin silver print,
signed
Print and image: 24.2 x 34.5 cm
HCB1951007W00975/30//2

Henri Cartier-Bresson: A Chronology

1908	Conceived in Palermo, Sicily.
	Born 22 August at Chanteloup, Seine-et-Marne. Has a close relationship with his uncle Louis, a painter.
	Educated at the Lycée Condorcet, Paris. No formal higher education.
1923	Develops a passionate interest in painting and aspects of surrealism.
1927–28	Studies painting under André Lhote.
1931	Spends one year in the Ivory Coast, where he takes his first photographs. Back in Europe, discovers the Leica, which becomes his favourite tool. Travels in Europe (including Italy and Spain) and concentrates on photography.
1933	Exhibits at the Julien Levy Gallery, New York.
1934	Spends a year in Mexico with an ethnographic expedition. Exhibits with Manuel Alvarez Bravo at the Palacio de Bellas Artes de Mexico in 1935.
1935	Spends some time in the USA, where he takes his first photographs of New York and first experiments with film, with Paul Strand. Exhibits at the Julien Levy Gallery for the second time, alongside Walker Evans and Manuel Alvarez Bravo.
1936–39	Works as second assistant to Jean Renoir on *La vie est à nous*, followed by *Une partie de campagne* and *La règle du jeu*.
1937	Directs a documentary on the hospitals of Republican Spain, *Victoire de la vie*, also a documentary for the Secours Populaire, *L'Espagne vivra*. Louis Aragon provides him with an introduction to Regards, where he publishes a number of photographic reportages, including coverage of the coronation of George VI.
1940	Taken prisoner by the Germans, escapes at his third attempt in February 1943.
1943	Takes a famous series of photographic portraits, including Matisse, Picasso, Braque and Bonnard.
1944–45	Works as part of a team photographing the Liberation of Paris. Directs *Le retour*, a documentary on the repatriation of prisoners of war and detainees.
1947	Spends over a year in the USA working on the so-called 'posthumous' exhibition of his work, proposed by the Museum of Modern Art in New York at a time when he was believed to have died in the war. Founds the cooperative agency Magnum Photos, together with Robert Capa, David 'Chim' Seymour, William Vandivert and George Rodger.
1948–50	In the Far East for three years: in India for the death of Gandhi, China for the last six months of the Kuomintang and the first six months of the People's Republic, and in Indonesia for independence.
1952–53	Back in Europe.
1952	His first book, *Images à la sauvette*, is published by Tériade, with a cover by Matisse.
1954	He is the first photographer to be allowed into the USSR during the period of détente. Publication of *Les danses à Bali*, marking the beginning of a long collaboration with Robert Delpire.
1958–59	Returns to China for three months for the tenth anniversary of the People's Republic of China.
1963	Returns to Mexico for the first time in thirty years, staying for four months. *Life Magazine* sends him to Cuba.
1969–70	Directs two documentaries for CBS News in the US.
1975	Concentrates on drawing but continues to practise portrait and landscape photography.
1986	Exhibition 'Henri Cartier-Bresson: The Early Work' at MoMA, New York, curated by Peter Galassi.
1988	Exhibition at the Centre National de la Photographie, organized by Robert Delpire. Creation of the Prix Henri Cartier-Bresson, awarded to Chris Killip in 1989 and Josef Koudelka in 1991.
2003	Retrospective exhibition 'HCB de qui s'agit-il?' at the Bibliothèque Nationale de France. Opening of the Fondation Henri Cartier-Bresson in Montparnasse, Paris.
2004	Henri Cartier-Bresson dies on 3 August in Montjustin.

Published on the occasion of the exhibition
Le Silence intérieur d'une victime consentante
at the Fondation Henri Cartier-Bresson, Paris, 18 January 2006 to 9 April 2006.

Text translated from the French by David H. Wilson

First published in 2006 in hardcover in the United States of America by
Thames & Hudson Inc., 500 Fifth Avenue, New York, New York 10110

thamesandhudsonusa.com

Library of Congress Catalog Card Number 2005909051

ISBN-13: 978-0-500-54317-7
ISBN-10: 0-500-54317-8

Printed and bound in Germany by Steidl, Göttingen